Zen Doodling

Carolyn Scrace

BARRON'S

First edition for North America, the Philippines,
and Puerto Rico published in 2013 by
Barron's Educational Series, Inc.

First published in Great Britain in 2013
by Book House, an imprint of The Salariya Book
Company Ltd

© The Salariya Book Company Ltd 2013,
25 Marlborough Place, Brighton BN1 1UB

All inquiries should be addressed to:
Barron's Educational Series, Inc.
250 Wireless Boulevard
Hauppauge, New York 11788
www.barronseduc.com

ISBN: 978-1-4380-0257-6

Library of Congress Control No. 2012948355

9 8 7 6 5

Printed and bound in China

Zen Doodling

Carolyn Scrace

Contents

Chapter One

Zen Doodling Basics

Zen Doodling is great fun and a wonderful way to relax. It enables those who lack artistic confidence to discover their latent talent. People often turn to art to deal with stress, trauma, and unhappiness—or just to find a sense of peace and meaning in their lives. Pablo Picasso once said, "Art washes away from the soul the dust of everyday life."

Creativity

Zen Doodling releases creativity and the repetitive nature of the designs focuses the mind and encourages a sense of inner calm and tranquillity. It can aid meditation. Zen Doodling can be done anywhere and needs no special equipment. Surprise yourself with the interesting and exciting results you create.

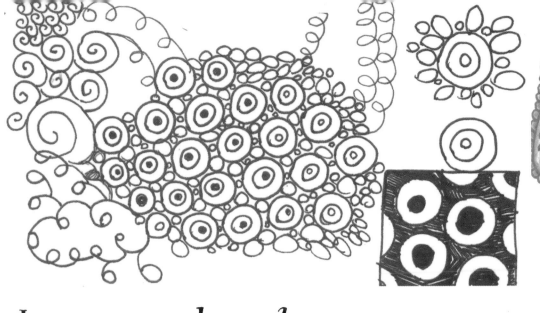

Learn and explore

This book explains how to start Zen Doodling from scratch, introducing simple, inspiring patterns with easy-to-follow instructions. Learn about tools and materials. Explore color theory. Helpful hints and tips are included to guide you.

Using themes

Find out how to construct mandalas, how to use themes, and how to frame your Zen Doodles. Discover potential sources of inspiration and how best to use them. Explore the potential of Zen Doodling: creating meaningful gifts, decorating 3-D objects, making greeting card designs, picture frames, and journals.

Unique

Explore a wide range of techniques, from printmaking to embossing. Embellish your mugs, T-shirts, and albums with your unique Zen Doodling.

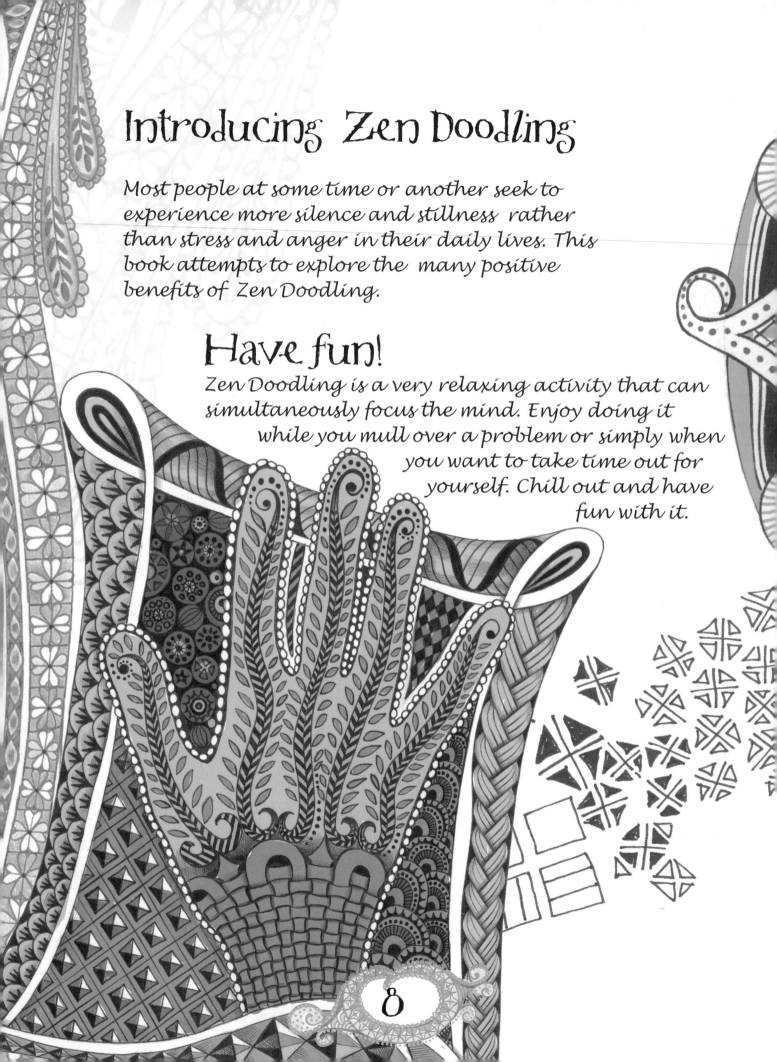

Introducing Zen Doodling

Most people at some time or another seek to experience more silence and stillness rather than stress and anger in their daily lives. This book attempts to explore the many positive benefits of Zen Doodling.

Have fun!

Zen Doodling is a very relaxing activity that can simultaneously focus the mind. Enjoy doing it while you mull over a problem or simply when you want to take time out for yourself. Chill out and have fun with it.

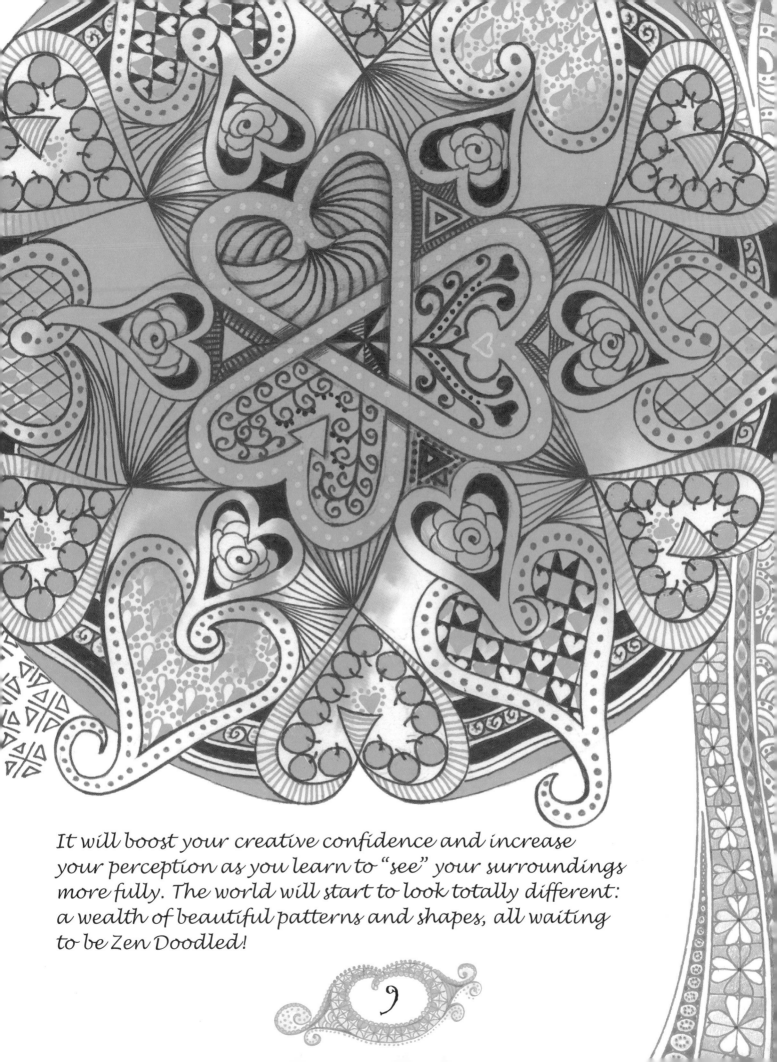

It will boost your creative confidence and increase your perception as you learn to "see" your surroundings more fully. The world will start to look totally different: a wealth of beautiful patterns and shapes, all waiting to be Zen Doodled!

Basic tools and materials

The tools and materials for Doodle art should not be expensive. Use any kind of pen or pencil and handy scraps of paper. Some of the best doodle art is on the back of receipts or paper napkins. If you want any special supplies for Zen Doodling, here are some suggestions:

Pencils and pens

Felt-tip pens; try using a variety of sizes.

Permanent markers are a must for doodling on lots of surfaces.

Gel pens will flow nicely on nearly any colored paper. A set of multicolored pens gives a huge range of colors.

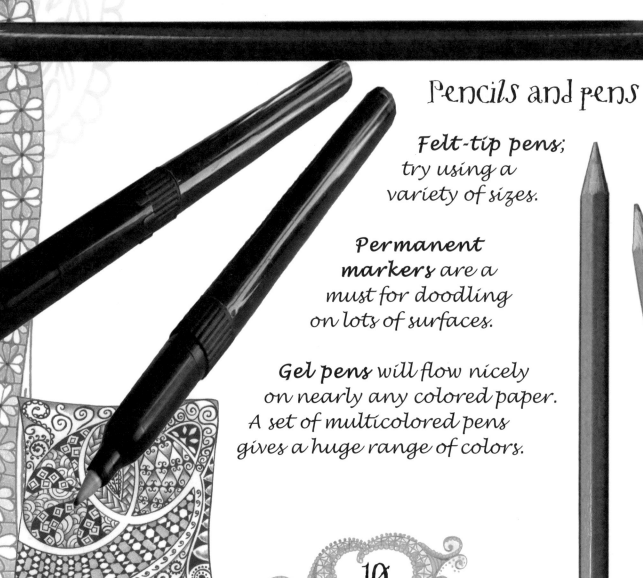

Paper

Bristol board (also known as Bristol paper) is an uncoated, machine-finished paperboard. It is named after the city of Bristol in the southwest of England. It is normally white but does come in a range of colors.

Line art paper is good if you want crisp lines. It is less absorbent than cartridge paper.

Cartridge paper is a heavyweight drawing paper that has a good surface for colored pencils. Ink lines tend to bleed on cartridge paper.

Just use whatever you prefer for drawing. Don't worry about having the "best" materials—this can make you more hesitant. Just draw!

Basic patterns
Building blocks

Draw a simple square, then add rectangles and shade them in. The initial square is the building block for you to explore using other combinations. See what patterns develop...

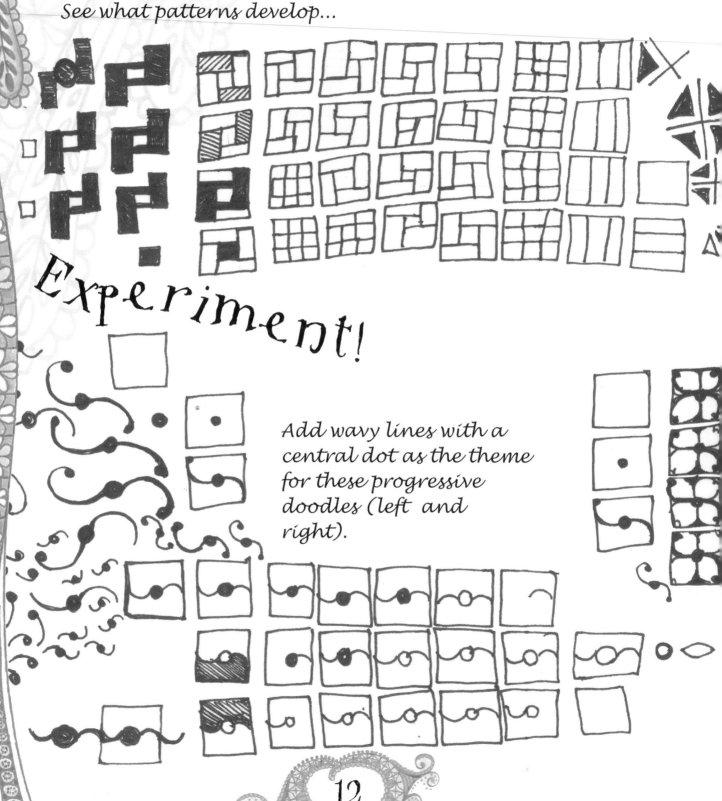

Experiment!

Add wavy lines with a central dot as the theme for these progressive doodles (left and right).

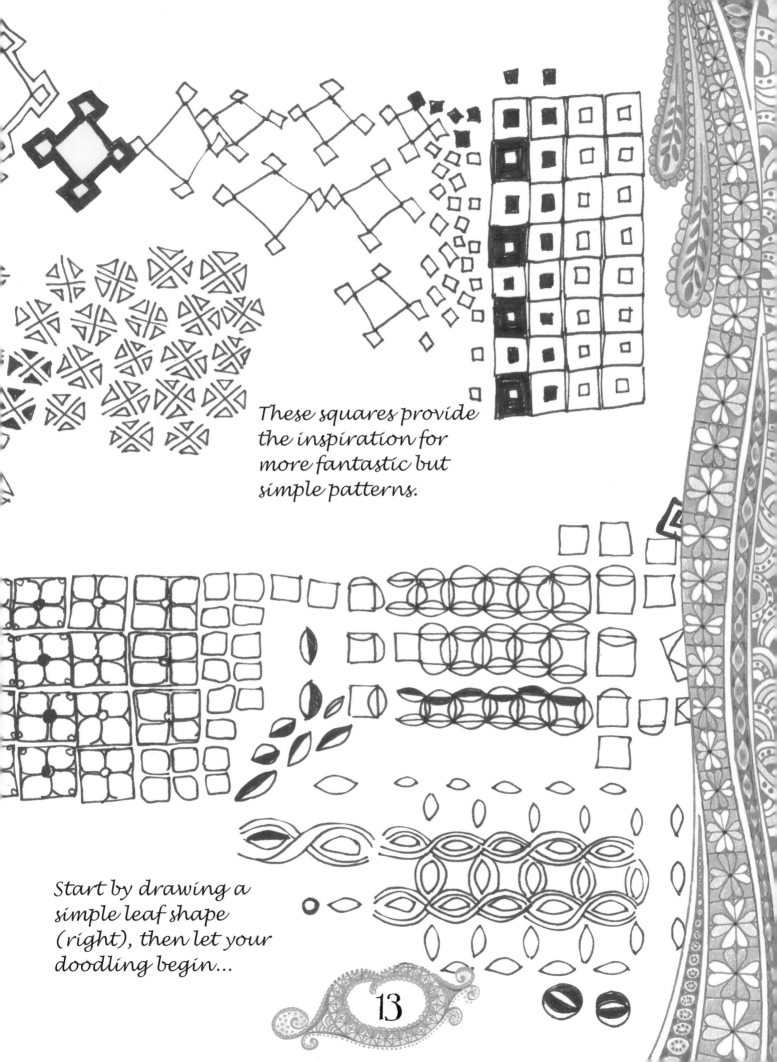

These squares provide the inspiration for more fantastic but simple patterns.

Start by drawing a simple leaf shape (right), then let your doodling begin...

13

More patterns...

Starting point

Draw an oval shape, then start to add different-sized ovals—you are already well on the way to creating fabulous patterns!

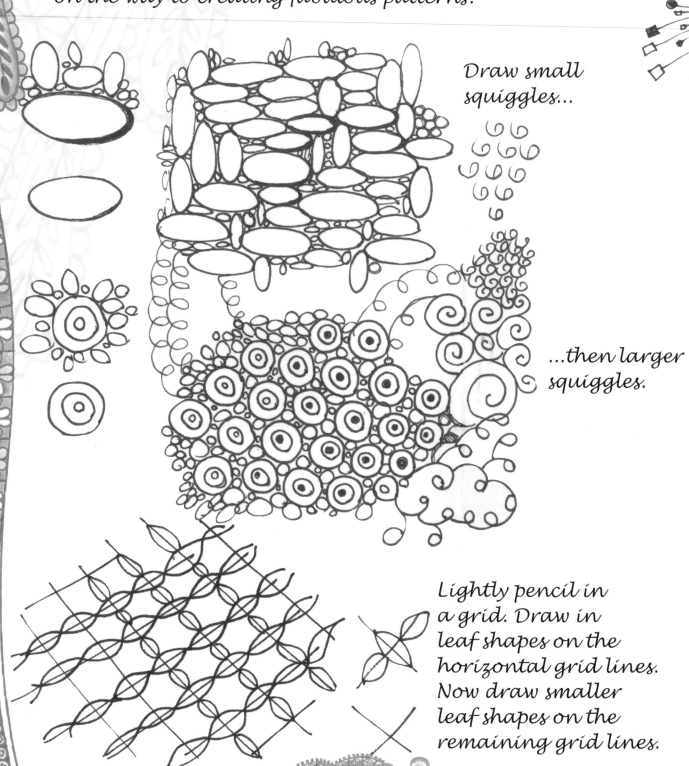

Draw small squiggles...

...then larger squiggles.

Lightly pencil in a grid. Draw in leaf shapes on the horizontal grid lines. Now draw smaller leaf shapes on the remaining grid lines.

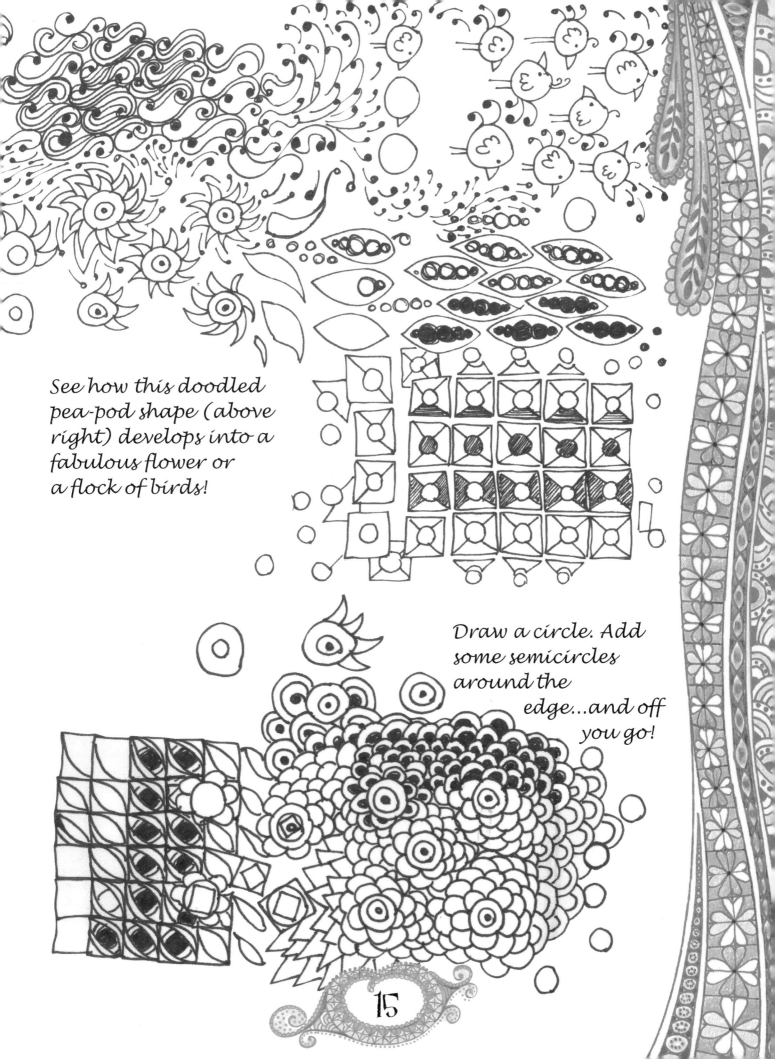

See how this doodled pea-pod shape (above right) develops into a fabulous flower or a flock of birds!

Draw a circle. Add some semicircles around the edge...and off you go!

Deconstructing
Breaking it down

If there is a particularly complicated pattern that you would like to doodle, first study the shapes, then break the design down into the main components.

To create this pattern (below), start by drawing in a pencil grid:

Add circular spirals where the grid lines cross.

Link the spirals vertically using curved lines.

Then draw in curved lines horizontally.

Add some pencil shading.

To create the 3-D pattern (below), start with a pencil grid:

Draw small squares within the grid boxes.

Add lines to connect the small and large squares.

Leave some areas white and color the others black or shades of gray.

For this flowery pattern, start by drawing a pencil grid:

Add solid black circles where the grid lines cross.

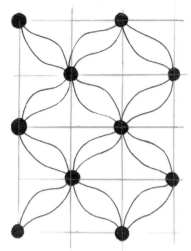

Link the black circles diagonally with curved lines.

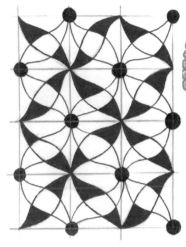

Draw in more curved lines across the first set. Color as above.

The woven pattern (below) requires a more complex grid:

Draw this grid (above).

Color in the smaller squares.

Add vertical curved lines as above.

Add horizontal curved lines as above.

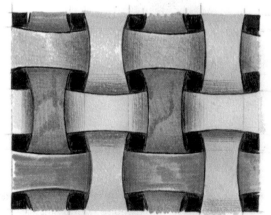

Use felt-tip pens and crayons to add contrasting colors to the woven strips. Use a pencil to add shading.

17

Getting started

When you first start Zen Doodling it is best to work on a small scale, using the materials that you have on hand.

Note: Each step of creating a Zen Doodle is highlighted in dark pink.

Pencil in a squarish shape on a small (3-4 in./75-100 mm square) piece of paper.

Now draw in simple shapes that divide it into different areas.

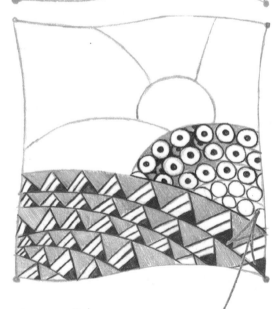

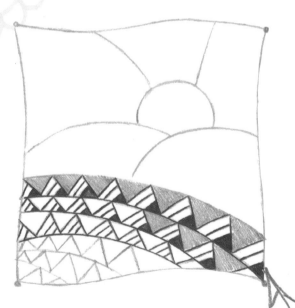

Lightly pencil in some guidelines. Use ballpoint pen to draw in your first doodle pattern.

Pencil in some more guidelines and ink in another doodle. Use a pencil to shade in the gray areas.

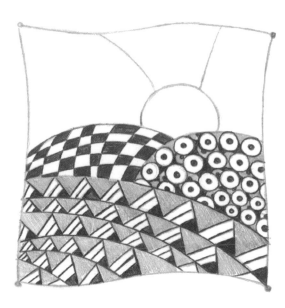

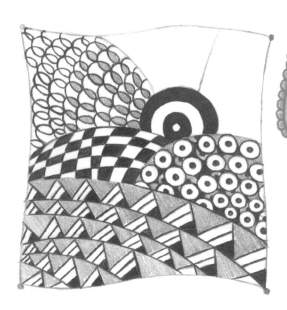

Always finish one area of doodle before moving on to the next.

Use simple doodle patterns at first—they can be just as effective as complex designs.

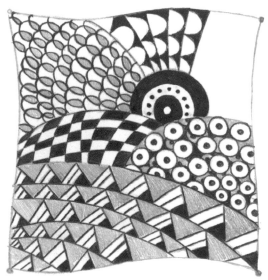

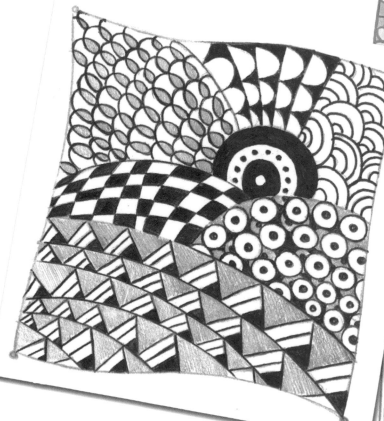

It is best to work in black and white before you introduce colors.

Keep your Zen Doodles in a notebook— they are wonderful sources of inspiration.

Light and Shade

Practice creating areas of pencil shading. Press down more firmly to make darker lines. Try using different types of pencil, from soft to hard.

Scribble

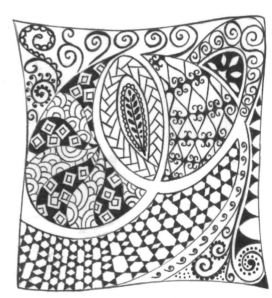

Hatching Cross-hatching Smudging

Experiment with shading techniques such as hatching, cross-hatching, or scribble. Vary the density of tone by making the hatched lines either farther apart or closer together. Try smudging the pencil shading.

1

2

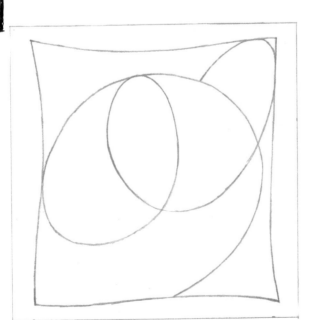

Pencil in a squarish shape. Doodle a series of loops.

Ink in areas of pattern until your Zen Doodle is complete.

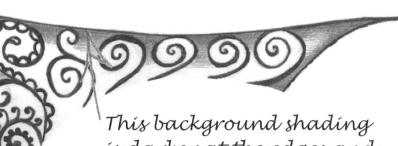

This background shading is darker at the edges and fades to white.

3

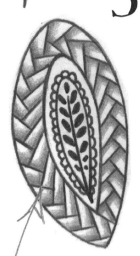

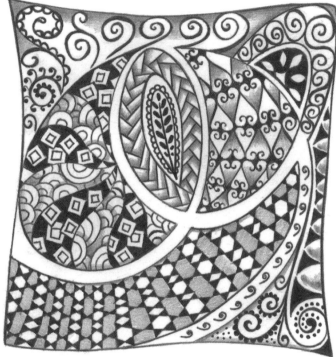

Graduated shading on these heart shapes adds a richness and depth to the doodle.

Gradated shading makes the plait look 3-D.

Use a pencil to shade in areas of your Zen Doodle.

Make white areas of the doodle look more prominent by lightly shading back other parts.

The shading used here makes these shapes look rounded.

Coloring tools and materials

Zen Doodling in color

The tools and equipment needed for Zen Doodling are fairly basic. Use any implement to create lines and choose any medium to add color. There are no rules as to what to use. Just experiment and discover what works best for you.

Experiment

Experiment by working on textured papers and different-colored papers!

Mixed media

Try using mixed media in your doodles. For example, color in with felt-tip pens, then work over the pattern with pencil crayons.

Sketch pad

Perfect for jotting down ideas and making sketches on the run. Carry a small set of pencil crayons to make notes of patterns and shapes that inspire you.

Fineliner pens come in a range of colors; they are ideal for coloring in delicate patterns.

Felt-tip pens come in many different colors and line widths. Choose pointed tips for detailed work.

Use a soft eraser to get rid of any unwanted construction lines.

Gouache is useful for large areas of flat color.

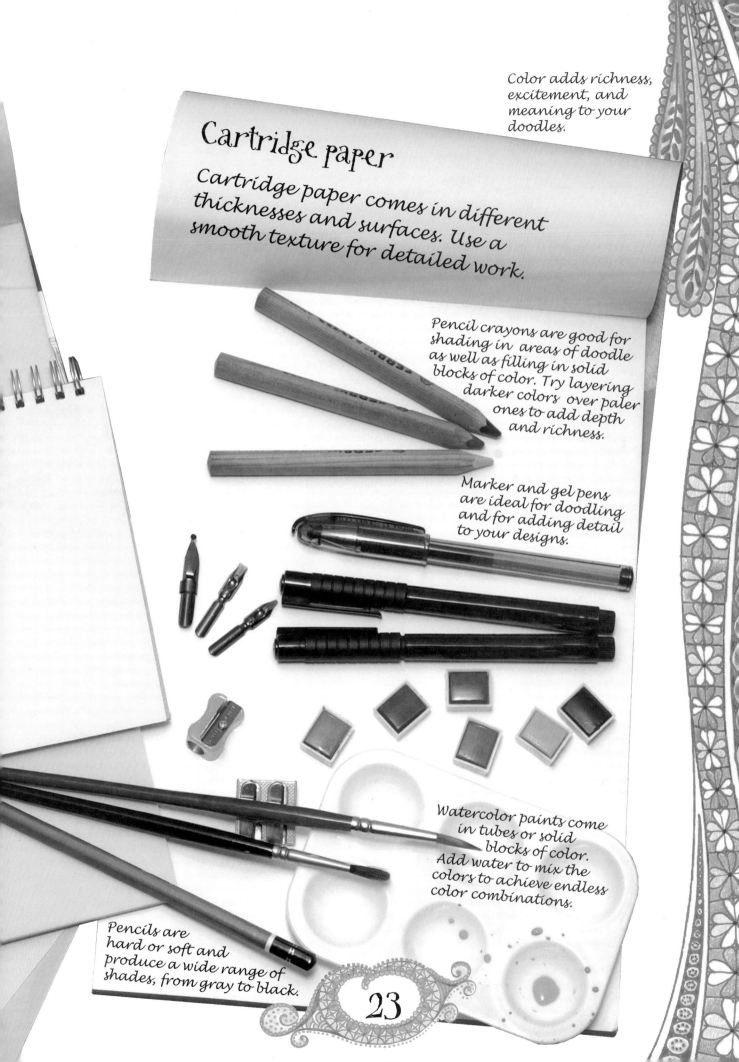

Cartridge paper

Cartridge paper comes in different thicknesses and surfaces. Use a smooth texture for detailed work.

Color adds richness, excitement, and meaning to your doodles.

Pencil crayons are good for shading in areas of doodle as well as filling in solid blocks of color. Try layering darker colors over paler ones to add depth and richness.

Marker and gel pens are ideal for doodling and for adding detail to your designs.

Watercolor paints come in tubes or solid blocks of color. Add water to mix the colors to achieve endless color combinations.

Pencils are hard or soft and produce a wide range of shades, from gray to black.

23

Basic color theory

Primary colors

The primary colors are red, yellow, and blue. They cannot be mixed from any other colors. All other colors are derived from these three primaries.

Secondary colors

The secondary colors are green, orange, and purple. They are created by mixing the primary colors.

Tertiary colors

Tertiary colors are yellow-orange, red-orange, red-purple, blue-purple, blue-green, and yellow-green. These colors are formed by mixing a primary and a secondary color.

Color temperatures

Warm colors (yellows, oranges, and reds) reflect passion, happiness, enthusiasm, and energy.

Cool colors (greens, blues, and purples) reflect calmness, tranquillity, and order. Changing the exact hue or saturation of a color can evoke a completely different feeling.

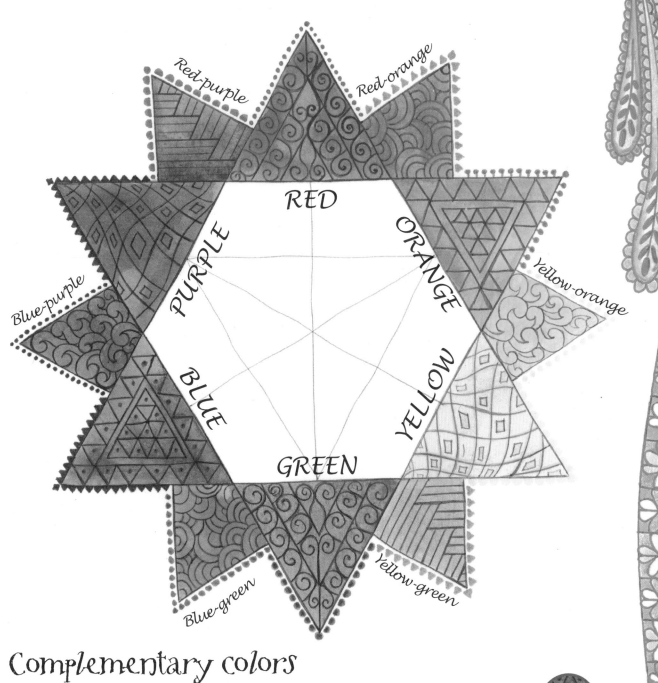

Complementary colors

Complementary colors lie diagonally opposite on the diagram (e.g., red and green, orange and blue). Use these combinations to create vibrant, clashing color schemes.

Analogous colors

These are colors that lie adjacent on the diagram (e.g., green and blue, purple and red). They produce harmonious color combinations.

25

Choosing a color scheme

Monochrome

A monochrome color scheme uses only one color but in different values (on the scale of lightness or darkness) and intensities (on the scale of brightness or dullness).

Working in a monochrome color scheme is a useful starting point, as it produces a very effective result while you build your confidence with color.

Color charts

The color charts (below) show clearly how the tonal value of a color affects it. Note the subtle changes when a small amount of an analogous color is added.

Colorful emotions

Red: *reflects life force, preservation, the sacred, blood, and fire. Red is energizing: it excites the emotions and motivates us to take action.*

Yellow: *reflects rootedness, renunciation, and earth. Yellow inspires original thought and inquisitiveness.*

Green: *reflects balance, harmony, vigor, youth, and action. Green is the color of equilibrium.*

Blue: *reflects coolness, infinity, ascension, purity, and healing. Blue is the color of reliability and responsibility, inner security, and confidence.*

White: *reflects learning, knowledge, purity, and longevity. White is the color of perfection, innocence, wholeness, and completion.*

Black: *reflects primordial darkness and hate. It is the color of things hidden, secretive, and unknown, creating an air of mystery.*

Creating borders

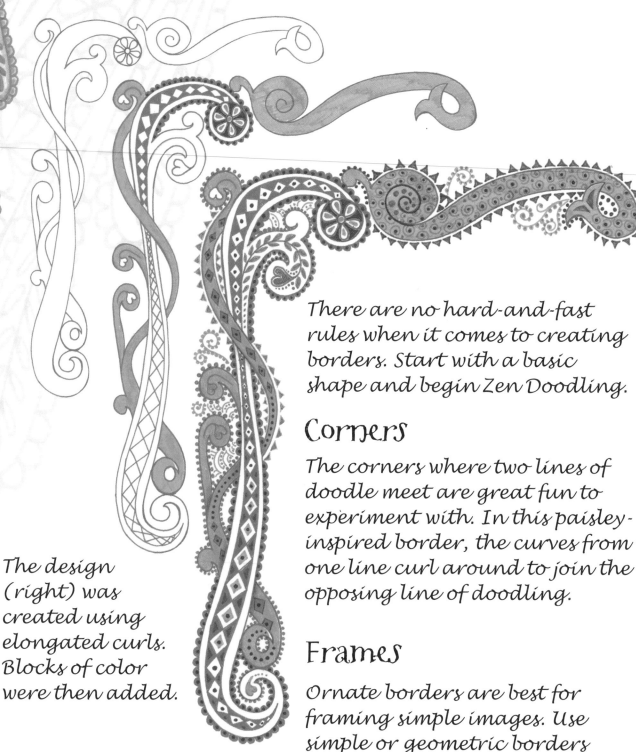

There are no hard-and-fast rules when it comes to creating borders. Start with a basic shape and begin Zen Doodling.

Corners

The corners where two lines of doodle meet are great fun to experiment with. In this paisley-inspired border, the curves from one line curl around to join the opposing line of doodling.

The design (right) was created using elongated curls. Blocks of color were then added.

Frames

Ornate borders are best for framing simple images. Use simple or geometric borders to frame complex images.

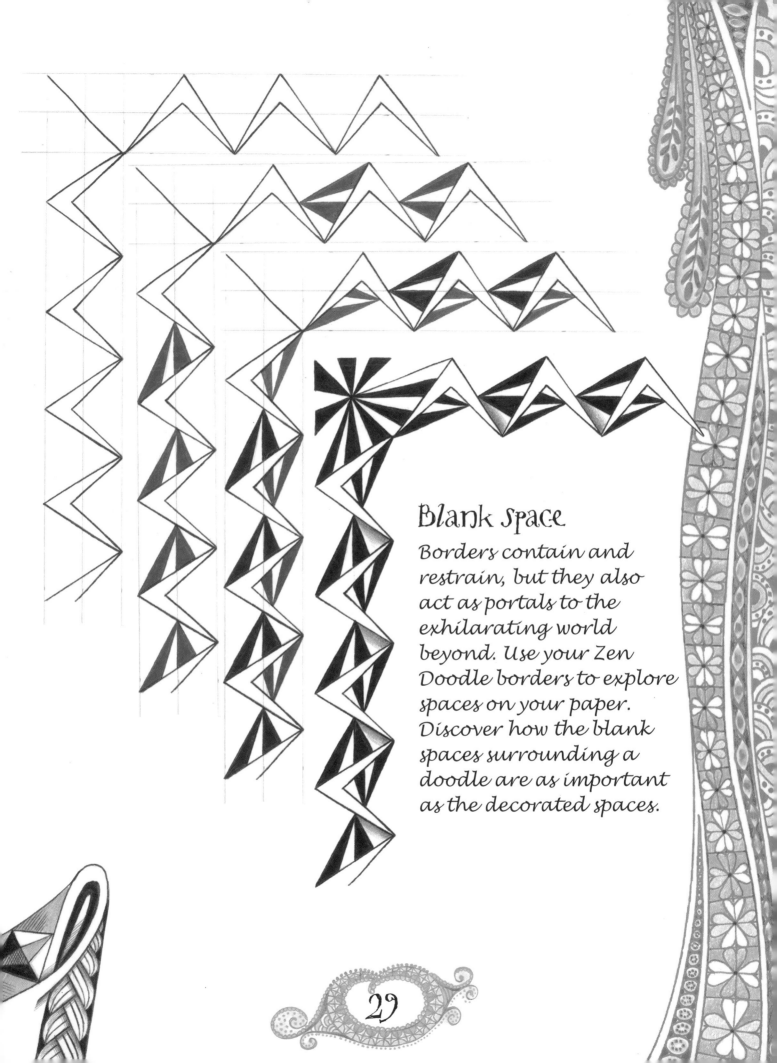

Blank space

Borders contain and restrain, but they also act as portals to the exhilarating world beyond. Use your Zen Doodle borders to explore spaces on your paper. Discover how the blank spaces surrounding a doodle are as important as the decorated spaces.

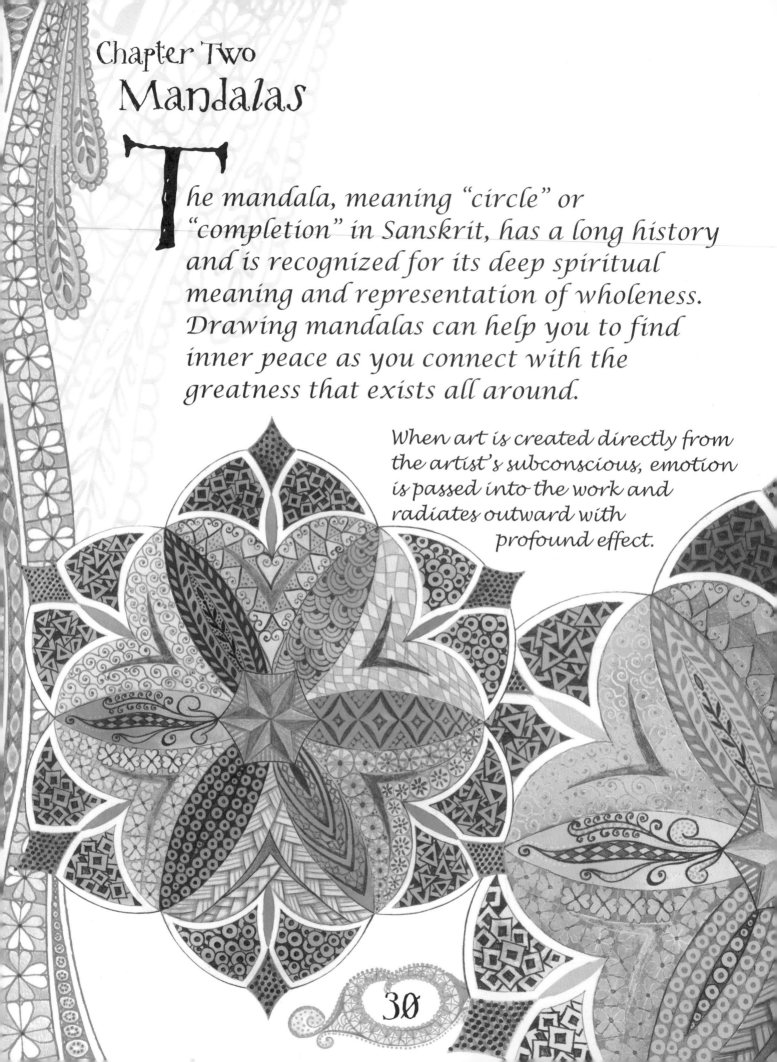

Chapter Two
Mandalas

The mandala, meaning "circle" or "completion" in Sanskrit, has a long history and is recognized for its deep spiritual meaning and representation of wholeness. Drawing mandalas can help you to find inner peace as you connect with the greatness that exists all around.

When art is created directly from the artist's subconscious, emotion is passed into the work and radiates outward with profound effect.

The circle represents the material world that continues endlessly. The center of the mandala symbolizes the beginning: a fountain of goodness and energy. Focus attention toward the center by keeping your design symmetrical and pointing inward.

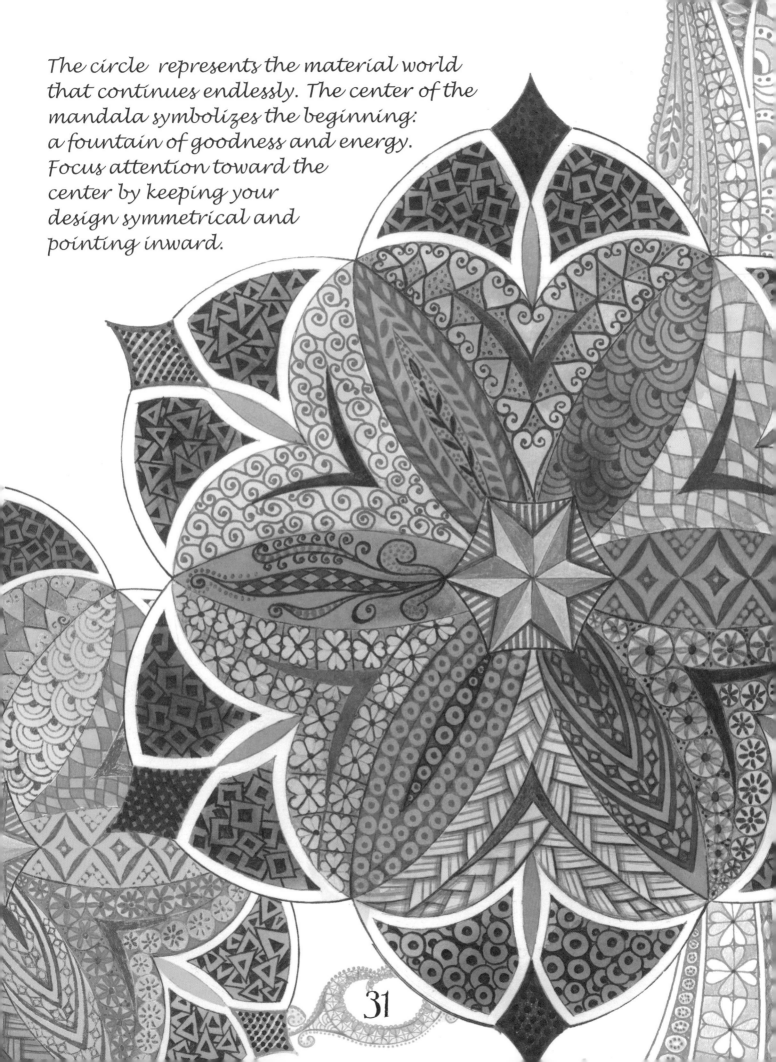

Getting started

The easiest and quickest method of drawing a mandala is to use a plate, cup, coin, or anything round as a template.

Small and simple

Try working on small, simple mandalas to start with. Work in black and white, then try using a limited palette before embarking on full-color versions.

Using a protractor

A protractor is very easy to use. It enables you to divide your mandala circle into any number of equal sections. There are 360 degrees in a circle, so if you want nine sections; divide 360° by 9 = 40°. Use the protractor to mark out increments of 40 degrees (80°, 120°, 160°, etc.).

Draw a circle. Add a horizontal line through the center. Position the protractor on the line and align it with the center.

Mark out the size of each section in degrees. Draw a line from the center to each marker.

Using compasses

If you want to create complex geometric mandalas it might be better to use compasses.

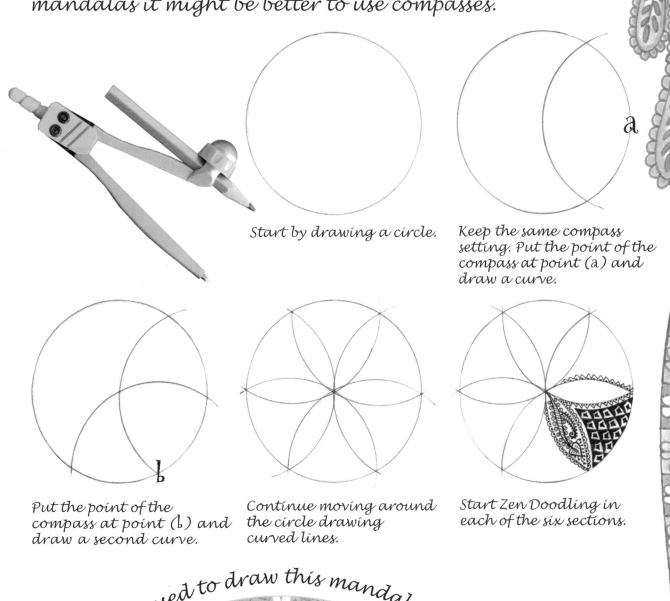

Start by drawing a circle.

Keep the same compass setting. Put the point of the compass at point (a) and draw a curve.

Put the point of the compass at point (b) and draw a second curve.

Continue moving around the circle drawing curved lines.

Start Zen Doodling in each of the six sections.

Compasses were used to draw this mandala.

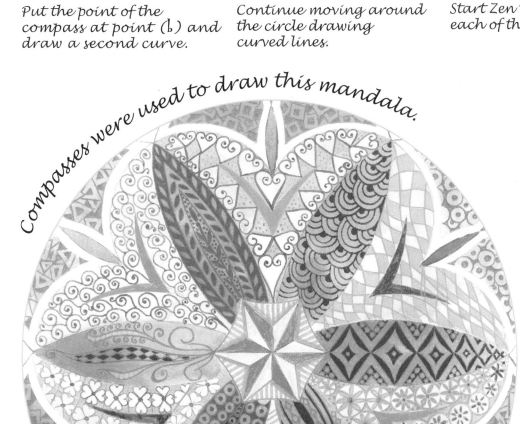

Symmetrical mandalas

The center

A mandala is a representation of the order of the universe, shown as a circular pattern that leads to a central point. Emphasize the importance of the goodness and energy at its core by focusing attention on the very center of your mandala.

Looking deeply into the circle of a mandala means that we must look deeply into ourselves. As you create a mandala, relax and open your mind to the peace and beauty, turmoil and unrest that exist at our center.

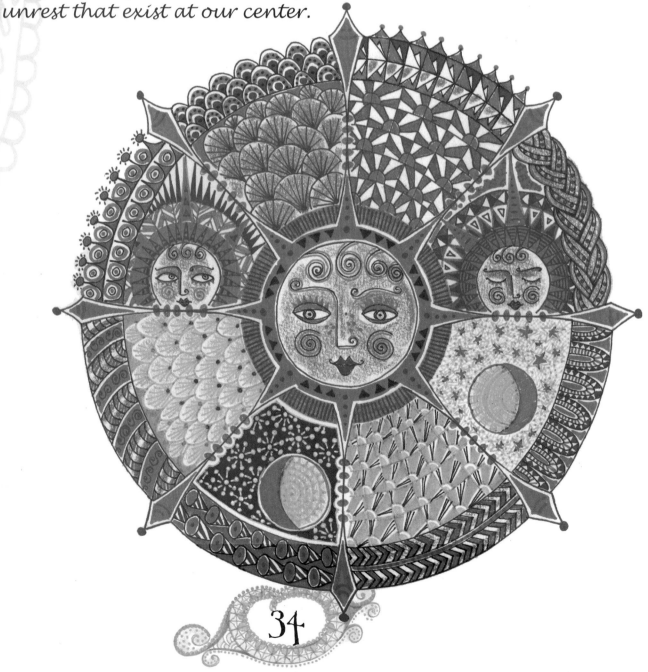

Symmetry

To create symmetrical balance, similar shapes must be repeated on either side of a vertical axis, as a mirror image. With a mandala, these shapes are also repeated on either side of the horizontal axis.

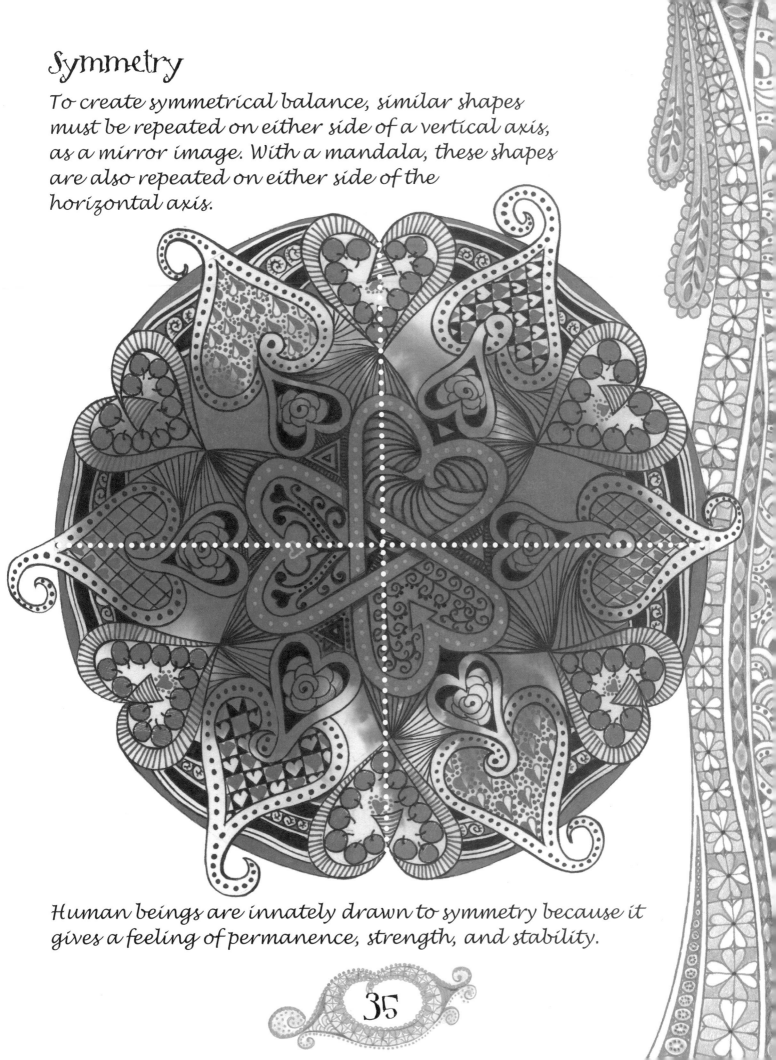

Human beings are innately drawn to symmetry because it gives a feeling of permanence, strength, and stability.

Mandalas inspired by nature

Be open to what you see. Let your mind relax, and bring yourself into the here and now. Look with wonder, as if through the eyes of a child, so that you see nature afresh. If you wish to find your inner truth, meditation will give you the deepest connection to unity outside yourself.

Create a template

Let nature inspire your Zen Doodles. Look at the shape of a spider's web, the center of a flower, the cross section of a tree trunk, or the shape of a shell. Use them to inspire your doodles or to create a template for your mandala.

Spiral

The exquisite spiraling structure of a fossilized ammonite inspired this mandala.

Start by drawing a circle. Now sketch in a spiral shape, working outward from the center. Extend the spiral beyond the circle, finishing it with a flamboyant swirl.

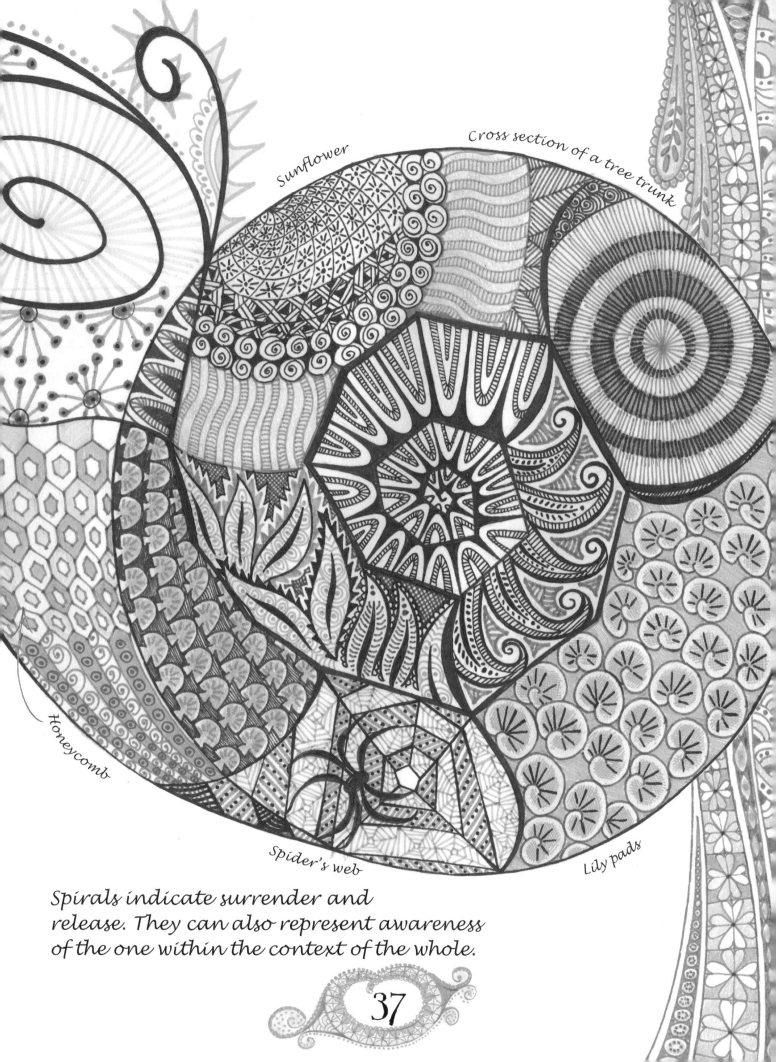

Sunflower

Cross section of a tree trunk

Honeycomb

Spider's web

Lily pads

Spirals indicate surrender and release. They can also represent awareness of the one within the context of the whole.

37

Snowflake mandalas

Snowflakes are made of ice crystals. They form incredibly beautiful six-pointed star shapes. Amazingly, no two snowflakes are the same!

Paper snowflake

A terrific way of creating a snowflake mandala is to make a paper template first.

Fold a circle of white paper in half. Now fold it into six sections along the dotted lines.

Second fold (a) to (c).

Third fold (d) to (b).

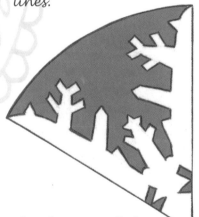

Sketch a snowflake design on your folded paper, then carefully cut it out. The pattern (above) created the snowflake shape (right).

The number six represents enlightenment, spiritual and mental balance, harmony, sincerity, love, and truth.

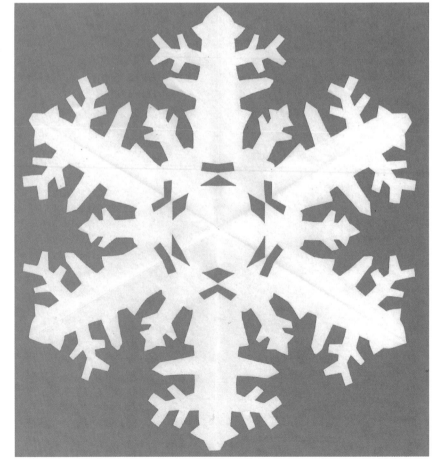

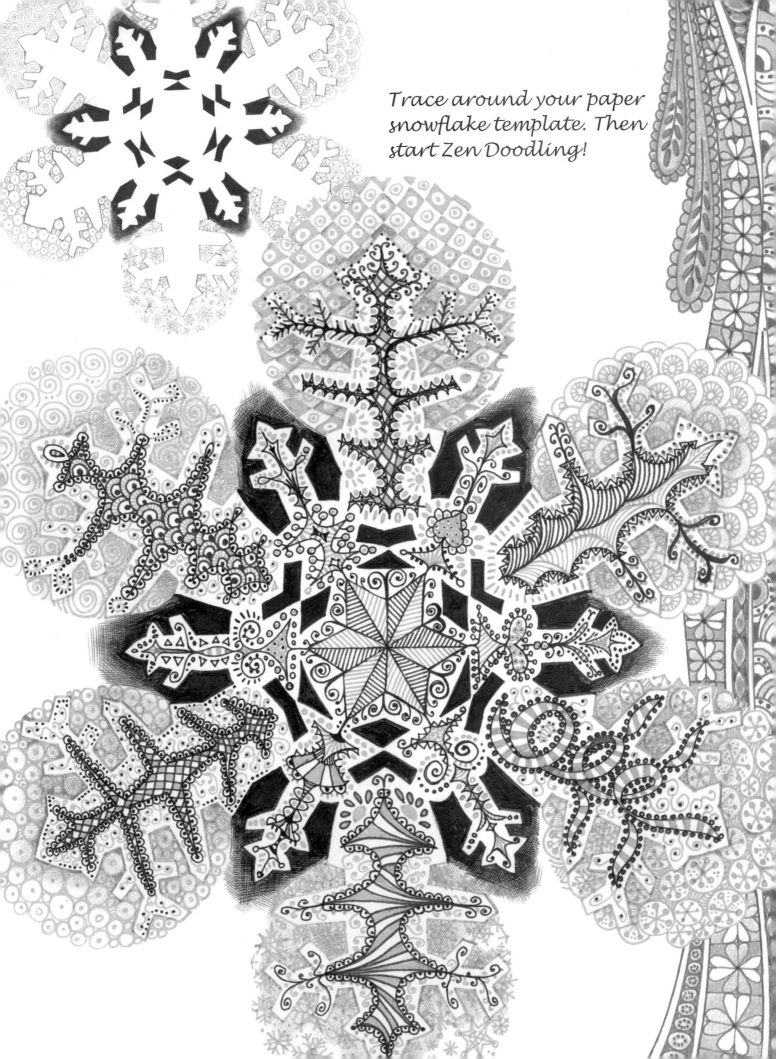

Trace around your paper snowflake template. Then start Zen Doodling!

The Circle of Life

Start by drawing a circle, the symbol of balance and symmetry. Divide it into sections, each reflecting a part of your life: for example, love, family, friends, work, and travel. As you fill in each section with doodles, try to include significant ideas that relate to that part of your life.

It is especially useful to make a rough sketch for this mandala. Once the main elements are drawn, you are free to let your mind recall memories, both happy and sad.

Graphic representation

In this Circle of Life mandala, a tree symbolically represents family, the apples being children and grandchildren. The falling leaves are a poignant reminder of family members who have passed away. Creating this type of mandala becomes a particularly moving and cathartic experience.

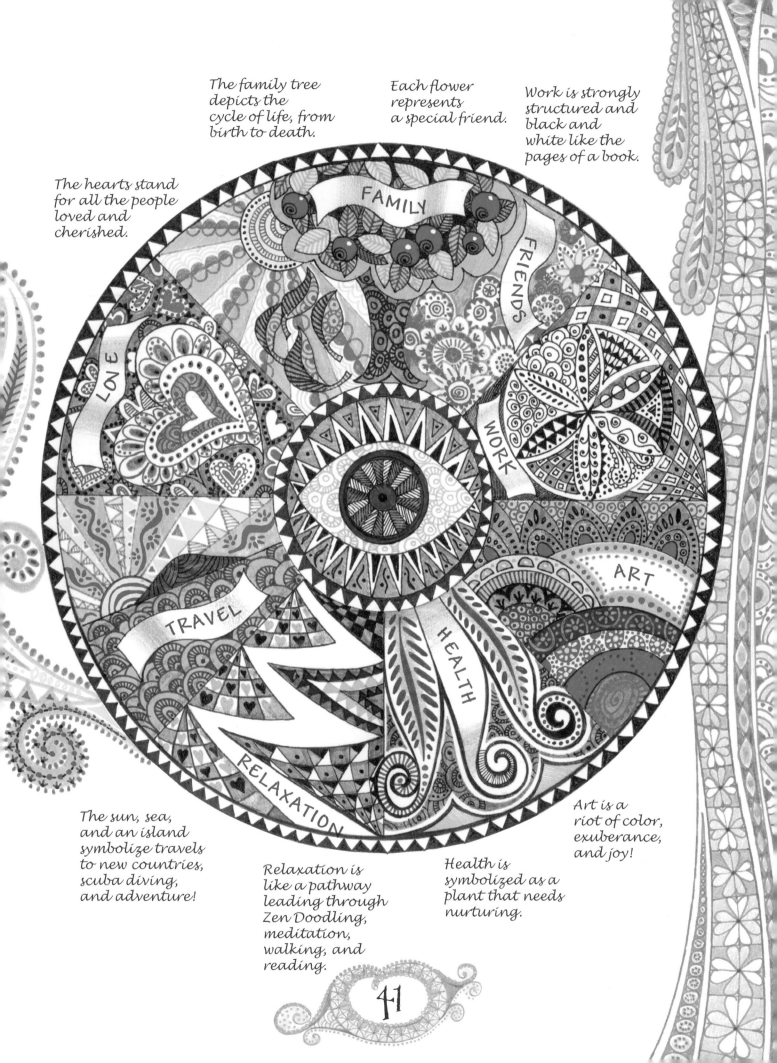

The family tree depicts the cycle of life, from birth to death.

Each flower represents a special friend.

Work is strongly structured and black and white like the pages of a book.

The hearts stand for all the people loved and cherished.

FAMILY

FRIENDS

LOVE

WORK

ART

TRAVEL

HEALTH

RELAXATION

The sun, sea, and an island symbolize travels to new countries, scuba diving, and adventure!

Relaxation is like a pathway leading through Zen Doodling, meditation, walking, and reading.

Health is symbolized as a plant that needs nurturing.

Art is a riot of color, exuberance, and joy!

41

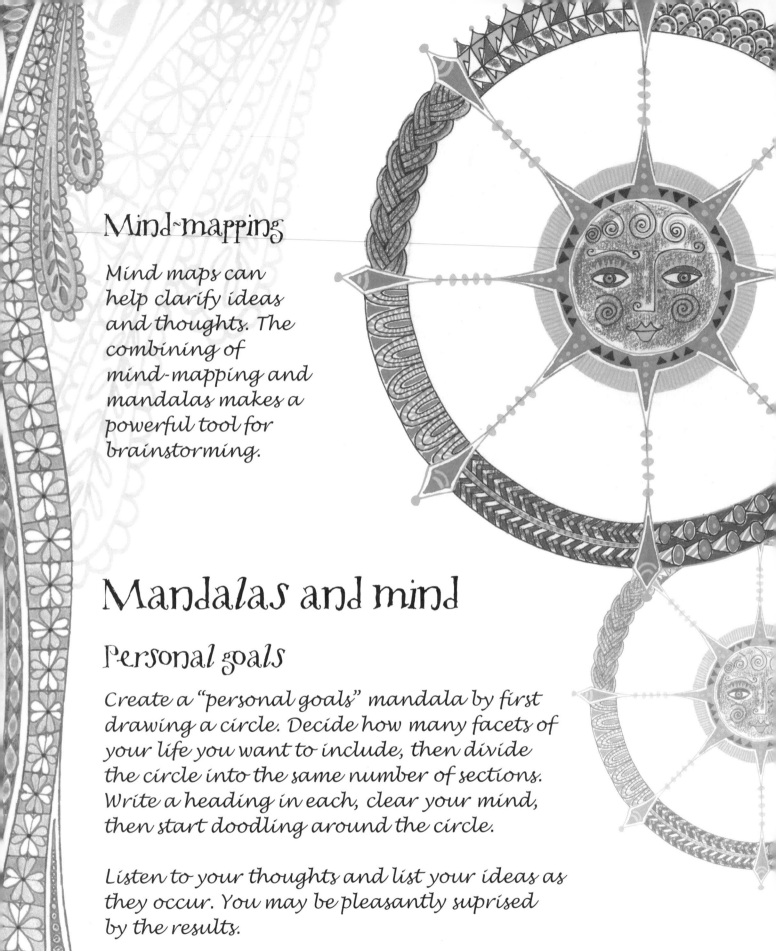

Mind-mapping

Mind maps can help clarify ideas and thoughts. The combining of mind-mapping and mandalas makes a powerful tool for brainstorming.

Mandalas and mind

Personal goals

Create a "personal goals" mandala by first drawing a circle. Decide how many facets of your life you want to include, then divide the circle into the same number of sections. Write a heading in each, clear your mind, then start doodling around the circle.

Listen to your thoughts and list your ideas as they occur. You may be pleasantly suprised by the results.

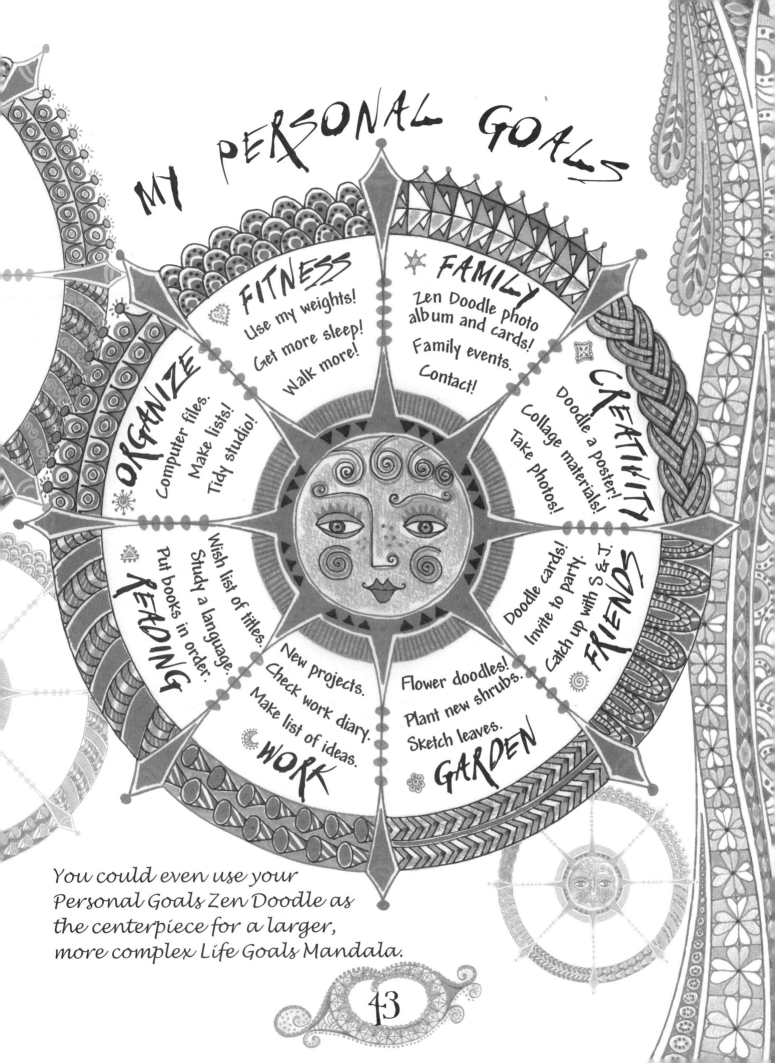

MY PERSONAL GOALS

FITNESS
Use my weights!
Get more sleep!
Walk more!

FAMILY
Zen Doodle photo
album and cards!
Family events.
Contact!

ORGANIZE
Computer files.
Make lists!
Tidy studio!

CREATIVITY
Doodle a poster!
Collage materials!
Take photos!

READING
Wish list of titles.
Study a language.
Put books in order.

FRIENDS
Doodle cards!
Invite to party.
Catch up with S & J.

WORK
New projects.
Check work diary.
Make list of ideas.

GARDEN
Flower doodles!
Plant new shrubs.
Sketch leaves.

You could even use your
Personal Goals Zen Doodle as
the centerpiece for a larger,
more complex Life Goals Mandala.

43

Yin and yang mandalas

Yin and yang are associated with female and male, dark and light, passive and active, stillness and motion. The yin and yang symbol is representative of balance, where two opposites coexist in harmony and are able to transmute into each other. The yin-yang symbol has a black dot of yin in yang and a white dot of yang in yin.

Symbolism

The outer circle symbolizes "everything" while the black and white shapes within represent the interaction of two energies, called "yin" (black) and "yang" (white). Yin is dark, passive, downward, cold, contracting, and weak. Yang is bright, active, upward, hot, expanding, and strong.

Start by drawing a circle. Then draw a smaller circle in the center with the yin and yang symbol. Draw two more yin and yang symbols beyond the central circle. Use felt-tip pen to color in the black areas.

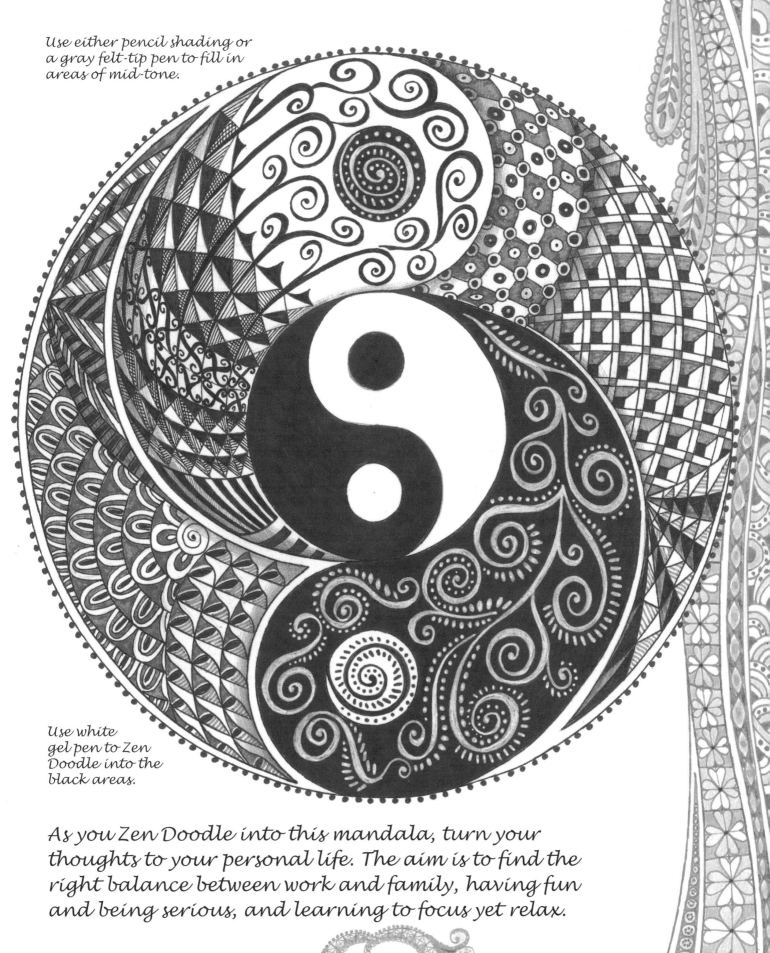

Use either pencil shading or a gray felt-tip pen to fill in areas of mid-tone.

Use white gel pen to Zen Doodle into the black areas.

As you Zen Doodle into this mandala, turn your thoughts to your personal life. The aim is to find the right balance between work and family, having fun and being serious, and learning to focus yet relax.

Water mandalas

Water is the driver of nature. It symbolizes purity, clarity, and calmness, reminding us to cleanse our mind and to attain a state of purity.

Six points

Draw a circle. Add a line through the center. Use the method shown on page 33 to divide the circle into six sections. Then start constructing your mandala.

Inspiration

Think of things you associate with water and let them inspire your doodles. For example, rain, clouds, raindrops, snow, icicles—the sun that heats the sky and the sea, waves, and sea creatures.

You may find it helpful to make a rough sketch of your mandala before starting the final version.

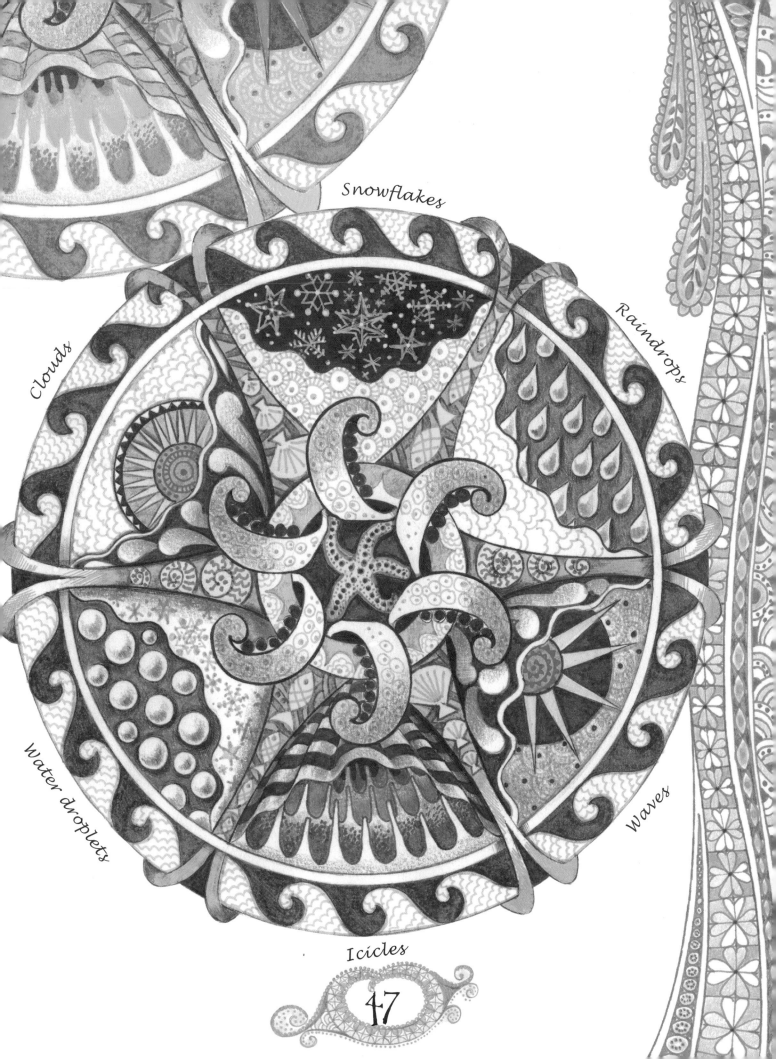

Snowflakes

Raindrops

Clouds

Water droplets

Waves

Icicles

47

Earth and nature mandalas

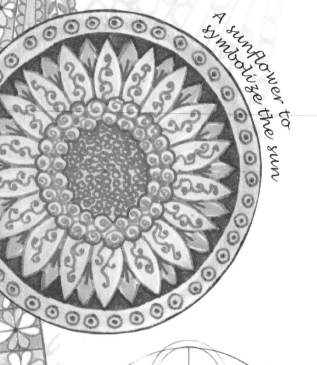

Spiritual freedom

Everything changes in nature; nothing remains static. The open air, natural habitats, and forest trees can all be seen as symbols of spiritual freedom. Consider the power of the sun and the contrasts between the four seasons, annual growth and rebirth, and the incredible diversity of life on our planet—Earth.

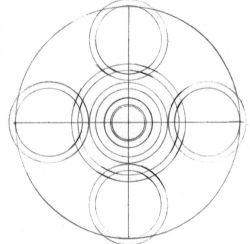

Draw a large circle, then add a smaller circle in the center to represent the sun. Draw a vertical and a horizontal line through both circles. Where these lines intersect the large circle, add four more small circles.

Four seasons

Spring

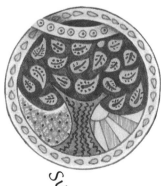

Summer

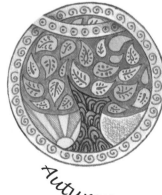

Autumn

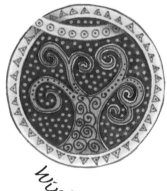

Winter

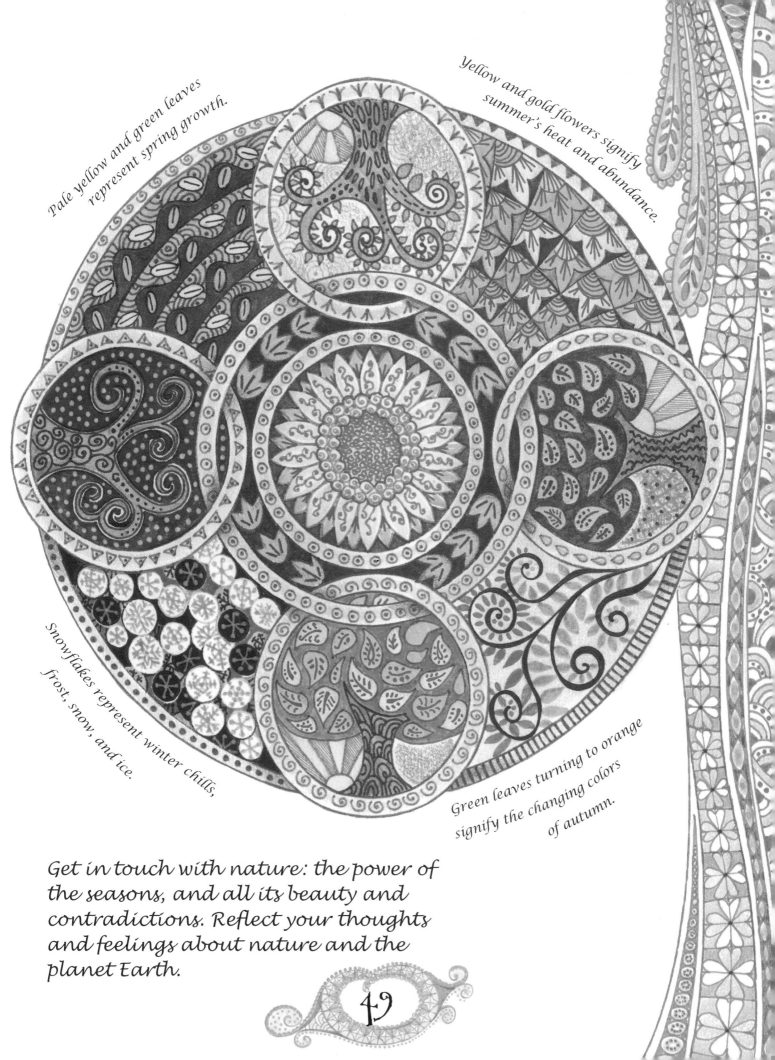

Pale yellow and green leaves represent spring growth.

Yellow and gold flowers signify summer's heat and abundance.

Snowflakes represent winter chills, frost, snow, and ice.

Green leaves turning to orange signify the changing colors of autumn.

Get in touch with nature: the power of the seasons, and all its beauty and contradictions. Reflect your thoughts and feelings about nature and the planet Earth.

49

Sun and moon mandalas

The power of the sun

The sun's tremendous power represents love, creative energy, vitality, spiritual growth, and passion for life. Keep this symbol in your thoughts, and tap into its infinite power and wisdom as you begin to work.

The moon and enlightenment

"Enlightenment is like the moon reflected on the water. The moon does not get wet, nor is the water broken. Although its light is wide and great, the moon is reflected even in a puddle an inch wide."

From **The Genjokoan** by Eihei Dogen

Draw a circle. Add a line through the center. Use a protractor to mark out 45, 90, and 135 degrees. Dissect the circle using these marks to achieve eight points.

As you build your mandala, integrate images of sunrise and sunset, and two phases of the moon's cycle. Contrast yellow, orange, and red (colors of the sun) with blues, grays, and blacks (colors of the night).

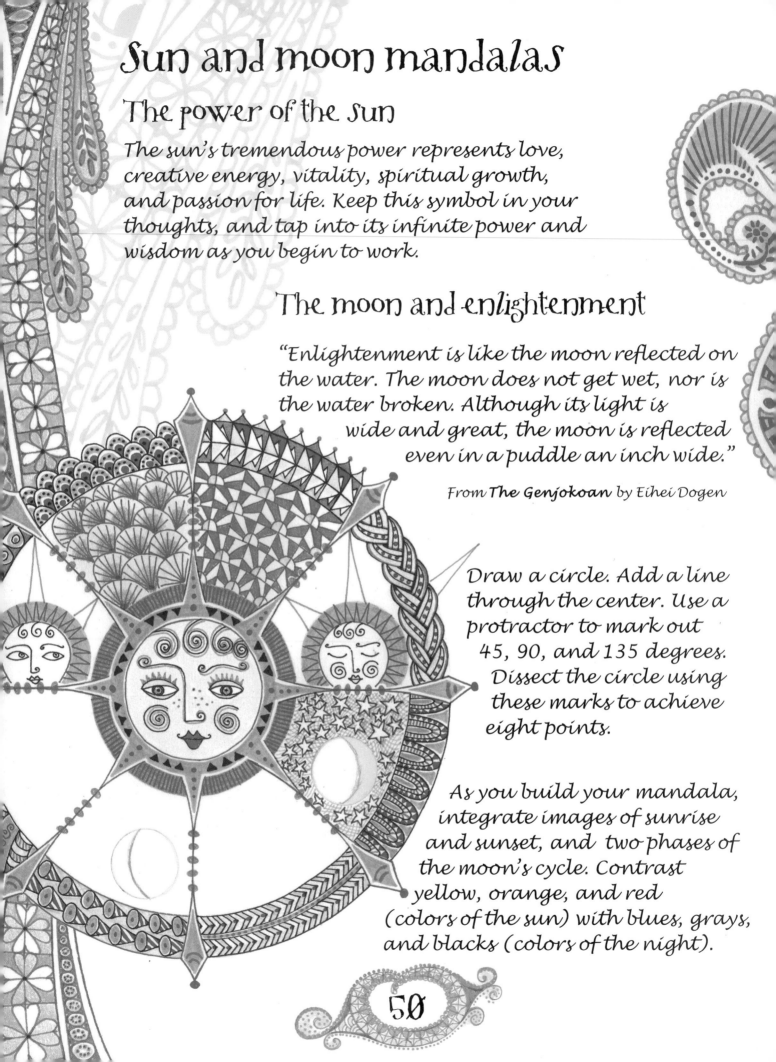

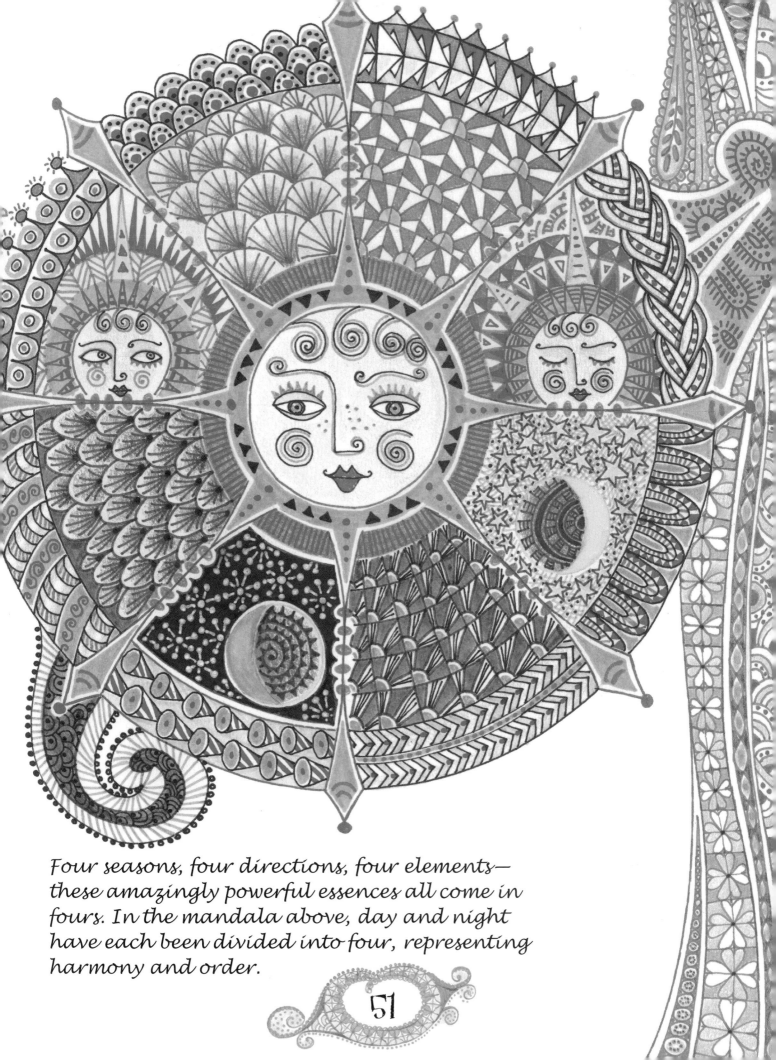

Four seasons, four directions, four elements—
these amazingly powerful essences all come in
fours. In the mandala above, day and night
have each been divided into four, representing
harmony and order.

51

Love mandalas

The heart and love

The heart shape has long been recognized as a symbol for love, charity, joy, and compassion. It evolved from the shape of an upturned triangle, which itself symbolizes a vessel into which love is poured. Triangles encourage the invocation of love energy to achieve a raised level of consciousness and union with the divine.

Rough sketch

Draw a line through the center of the circle. Using a protractor, mark out twelve 30-degree sections. Then start drawing in heart shapes.

Ink-blot inspiration

Once you are happy with the rough layout of your mandala, try creating an ink-blot background. Draw a circle on a sheet of watercolor or cartridge paper. Use a large, clean paintbrush to wet the circle and then drip ink into the center. Let the ink dry, then trace your rough design onto it.

As you start doodling, use shapes that have meanings related to the theme of love. The shell symbolizes the protective nature of love. Roses represent sensuality, purity, and romance. Apples can symbolize ecstasy, fertility, and abundance as well as love.

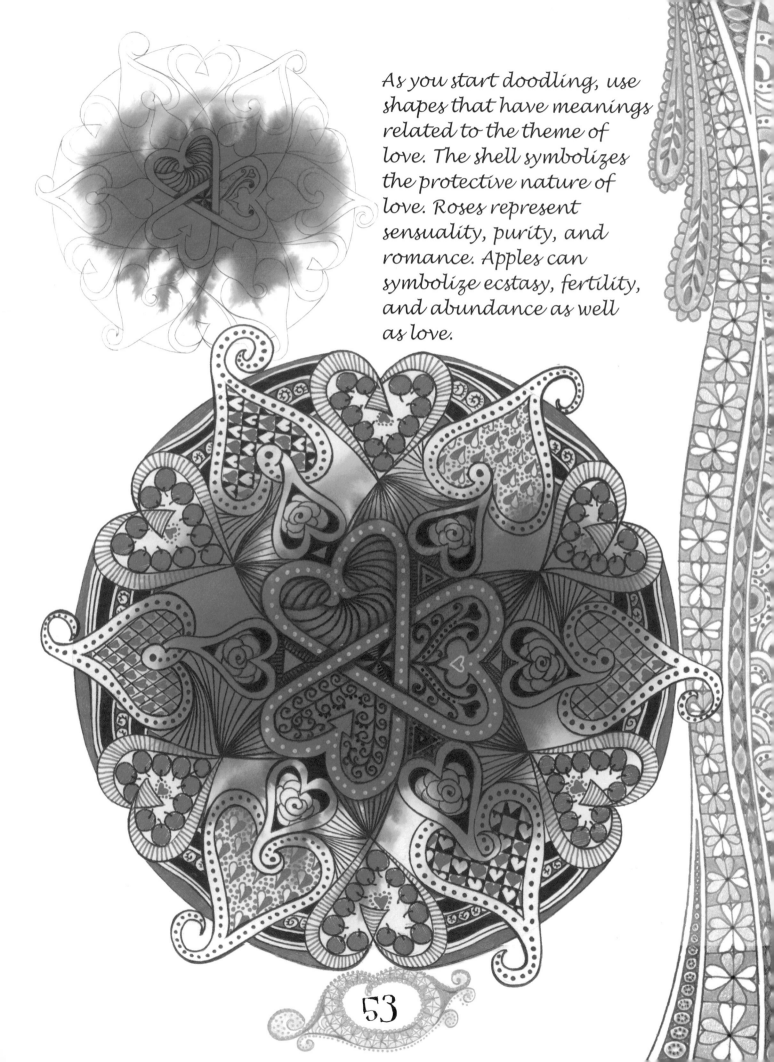

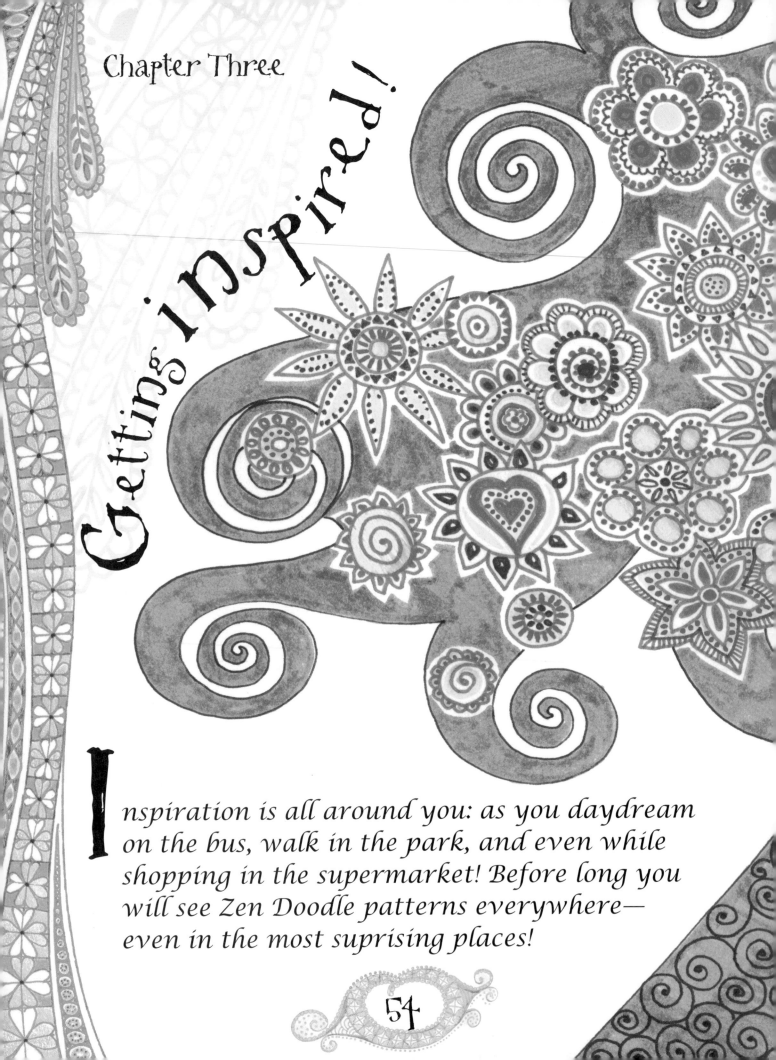

Chapter Three

Getting inspired!

Inspiration is all around you: as you daydream on the bus, walk in the park, and even while shopping in the supermarket! Before long you will see Zen Doodle patterns everywhere— even in the most suprising places!

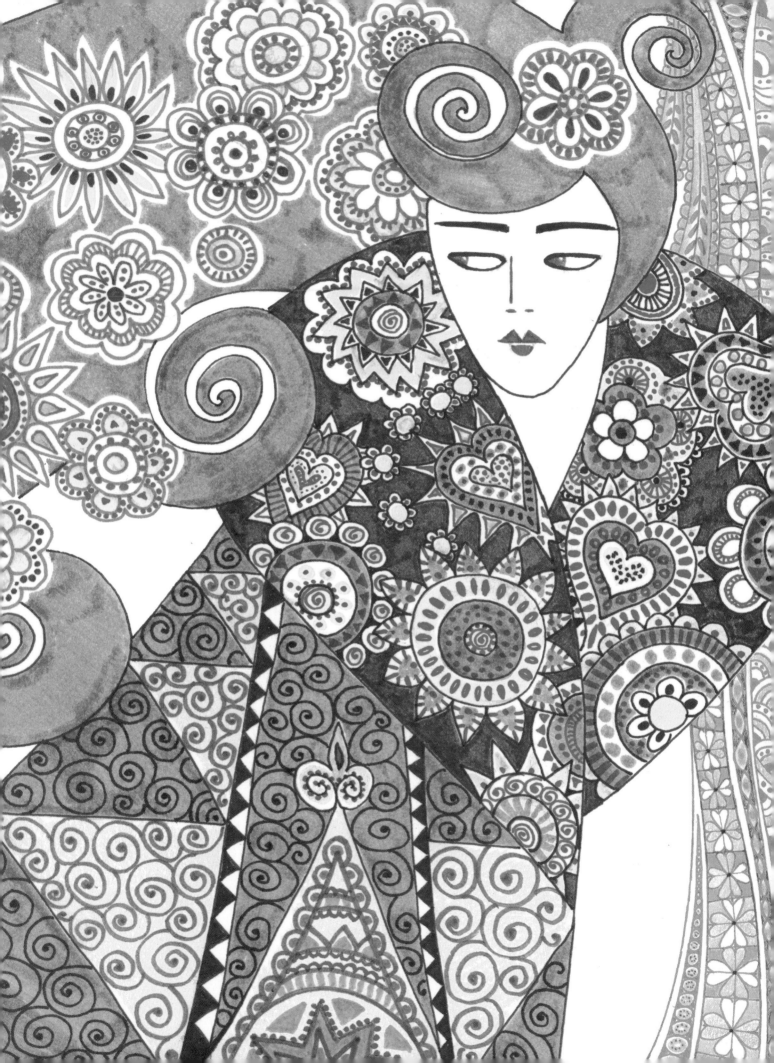

Zen Doodling on the go

Use your sketchbook for creative doodling and lots of experimental ideas. Stick in any inspiring magazine cuttings you find along the way. Above all, use your sketchbook. Don't be too concerned about how good it looks—it is a work in progress.

Inspiration from a sketchbook

Pages from a sketchbook to show how themes can be developed.

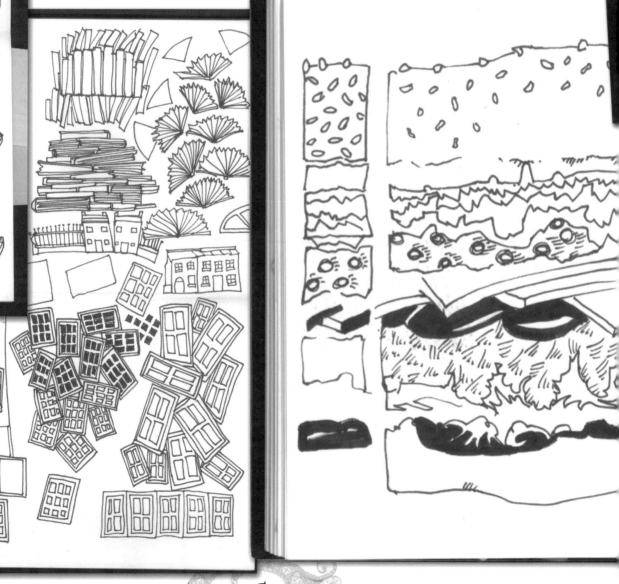

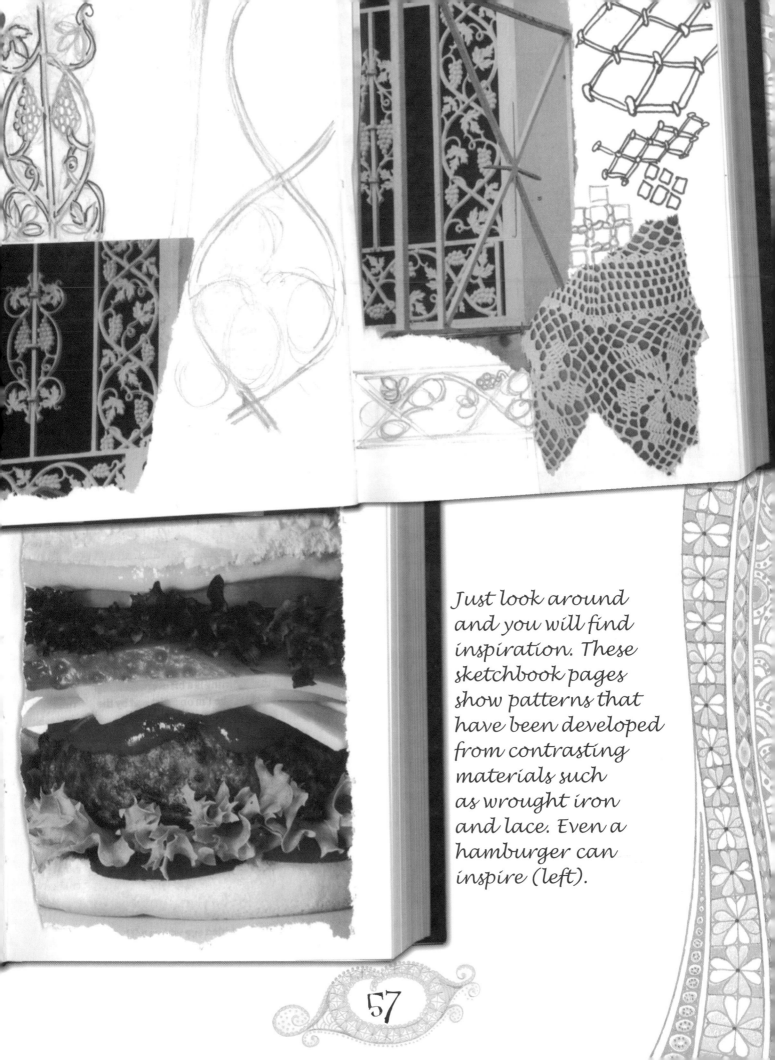

Just look around and you will find inspiration. These sketchbook pages show patterns that have been developed from contrasting materials such as wrought iron and lace. Even a hamburger can inspire (left).

Architectural doodles

Look around you at buildings and try to spot patterns: glass windowpanes, brickwork, or decorative features. Or find inspiration from magazine pictures. Draw lots of simple shapes in your sketchbook. Your observation and quick sketches can be developed into interesting pattern ideas. This Zen Doodle of buildings uses very simple shapes, mostly squares, rectangles, and triangles, to build up the picture.

Patterns in buildings

Observe and record basic shapes in your sketchbook.

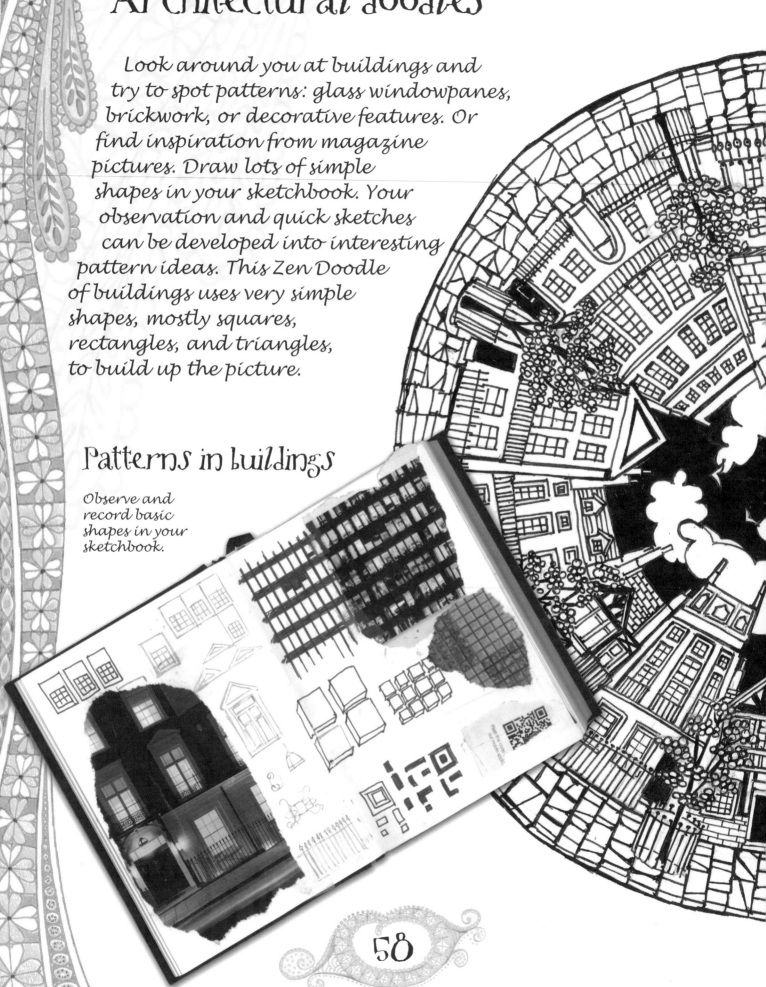

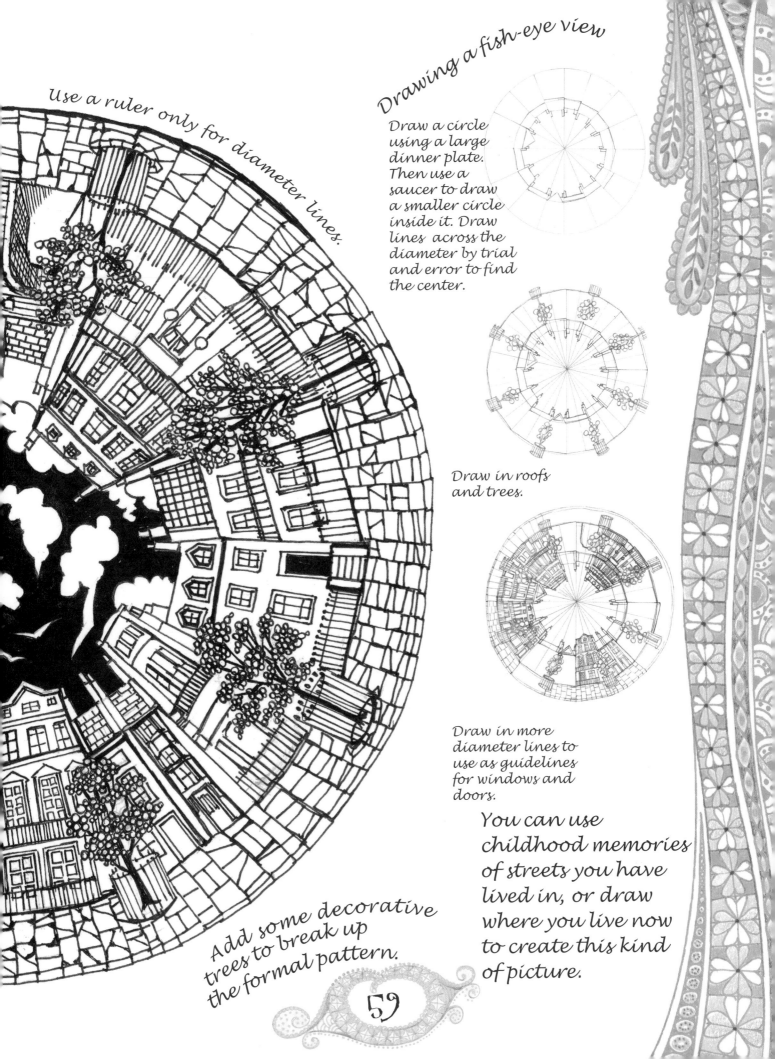

Use a ruler only for diameter lines.

Draw a circle using a large dinner plate. Then use a saucer to draw a smaller circle inside it. Draw lines across the diameter by trial and error to find the center.

Draw in roofs and trees.

Draw in more diameter lines to use as guidelines for windows and doors.

You can use childhood memories of streets you have lived in, or draw where you live now to create this kind of picture.

Add some decorative trees to break up the formal pattern.

59

Plants

The sinuous natural forms of plants and flowers are ideal sources of inspiration to create Zen Doodles. Lightly pencil in the main curving lines that will weave through your picture. It is important that you capture the mood of a garden border, as you are not trying to create a realistic representation of a garden.

Patterns in flowers

Look for patterns in nature. When you are drawing plants, think of the way they grow. The sketchbook (below) shows the branches of trees in winter.

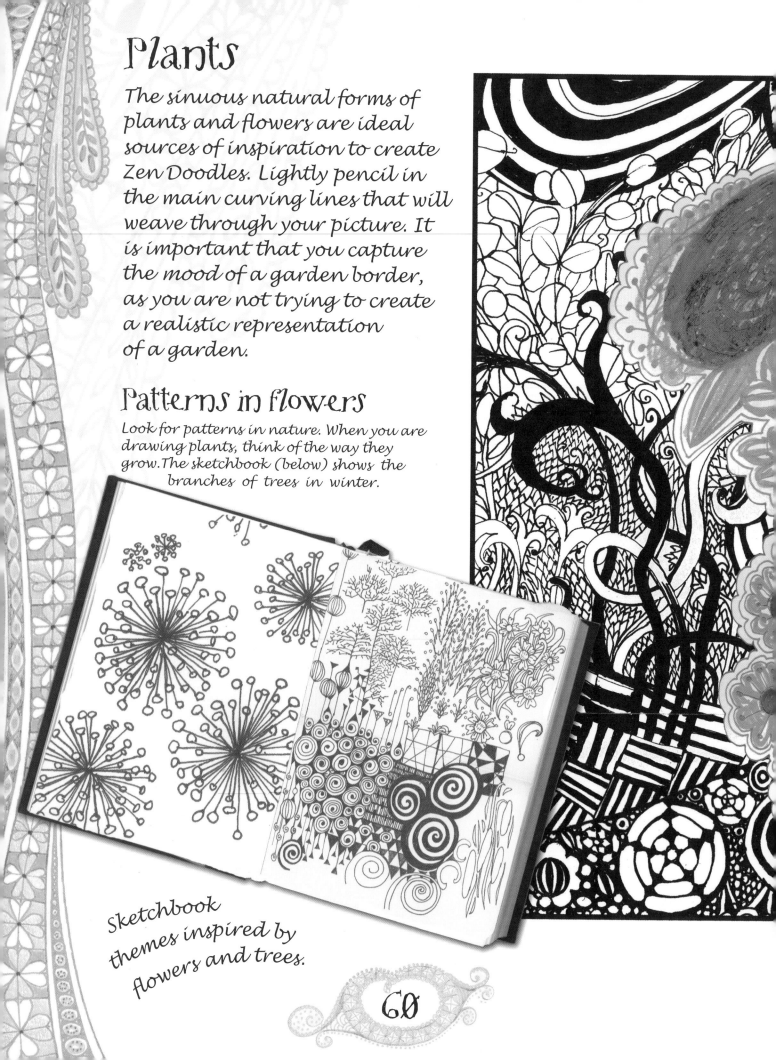

Sketchbook themes inspired by flowers and trees.

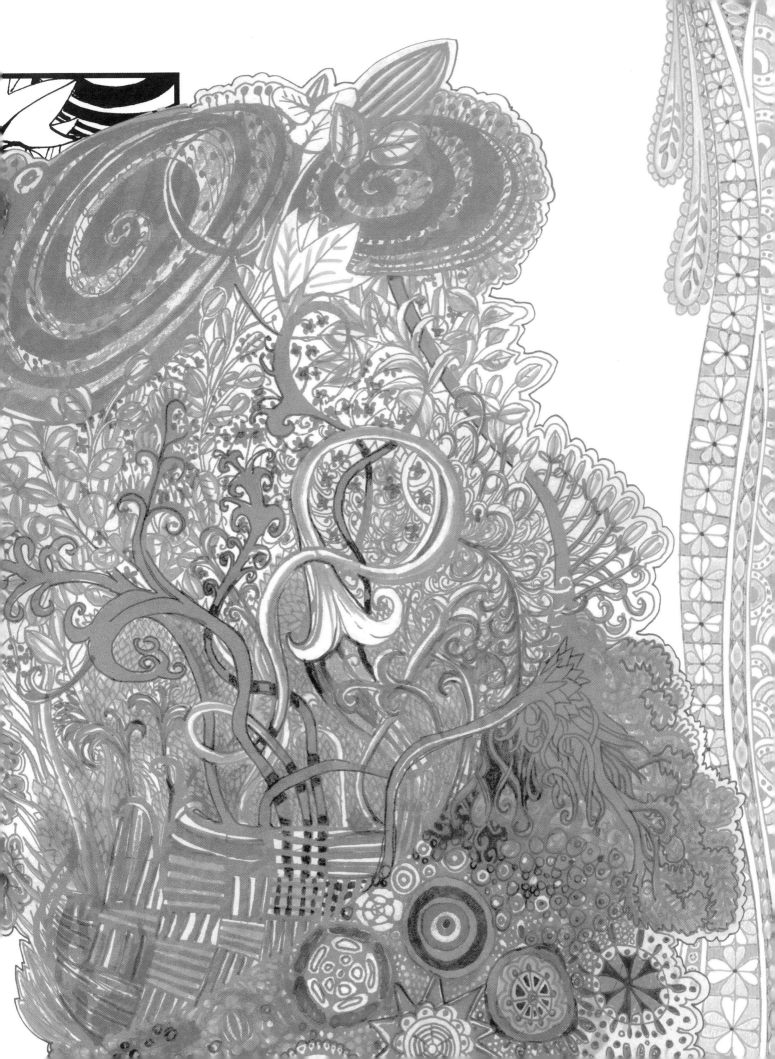

Textiles and fabrics

Your sketchbook is perfect for collecting cuttings from magazines and small samples of fabrics that inspire you. Keep adding creative doodles and exploratory drawings. Use it as a day-to-day diary of your thoughts and ideas. The more you doodle, the more confident and creative you will become.

Patterns in flowers

Fabric patterns are a great source for Zen Doodle ideas. Collect photographs and drawings of flowers or plants so you can study them to simplify the shapes you want to use.

Sketchbook pages with flowery, cloud-, and bird-inspired themes.

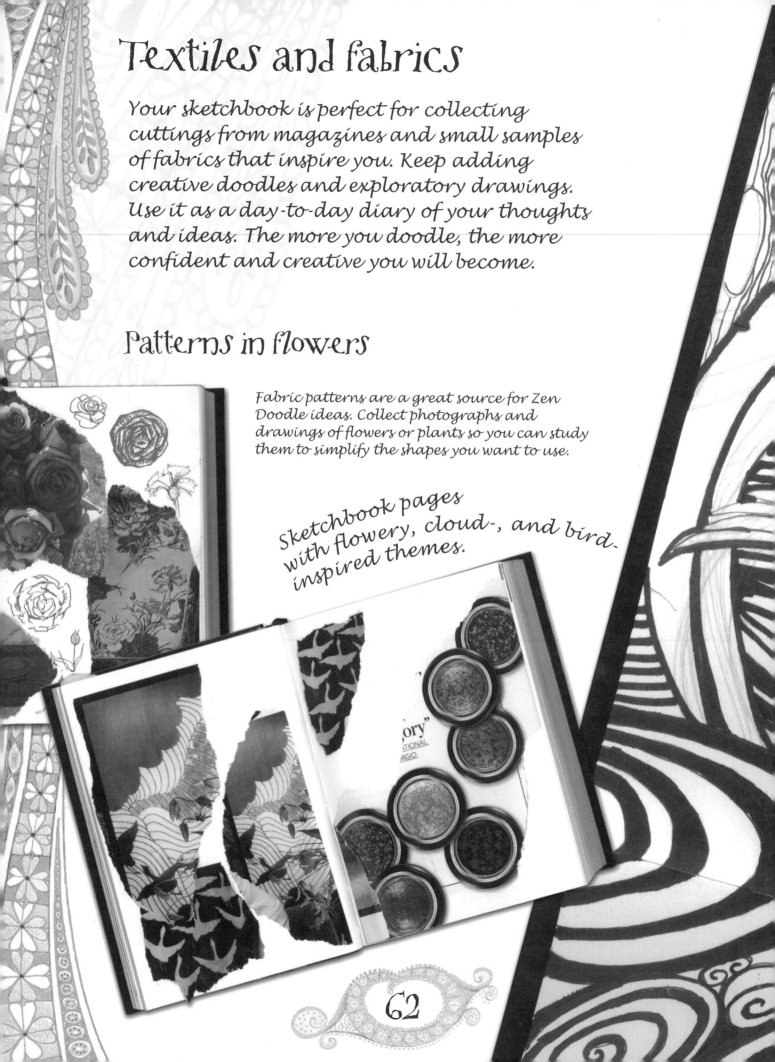

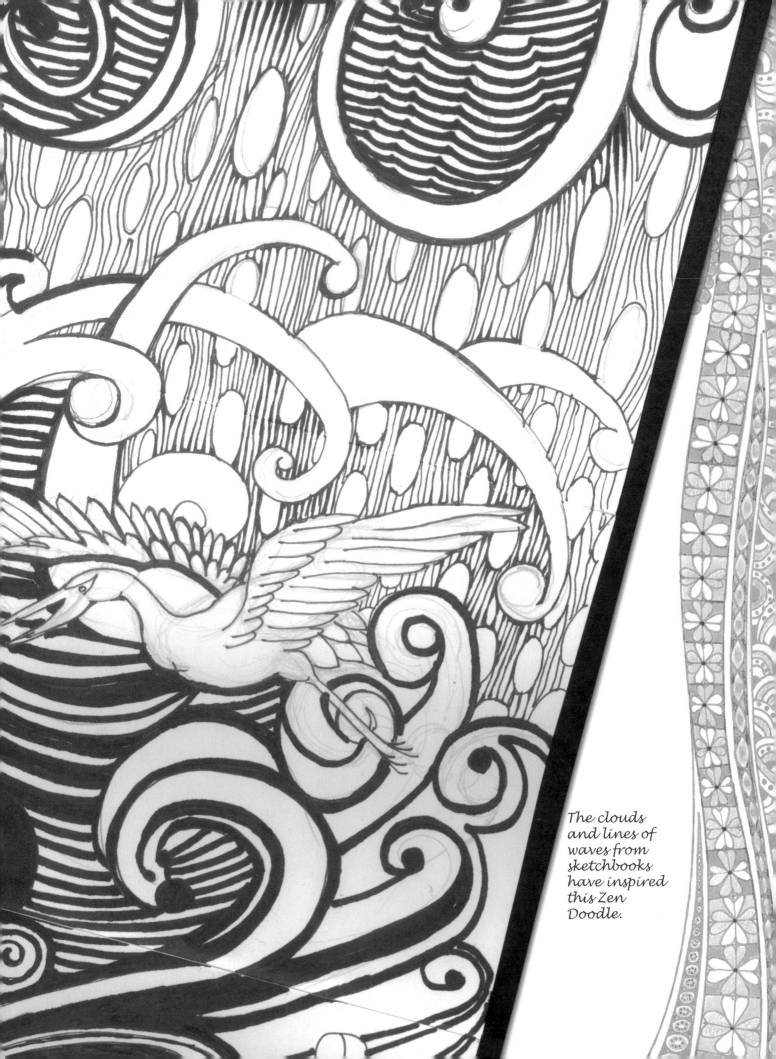

The clouds and lines of waves from sketchbooks have inspired this Zen Doodle.

Favorite things

Bold design

Sunshine, wild animals, birdsong, flowers, rolling meadows, the sea, and scuba diving have been included in this Zen Doodle. This bold design uses a tree motif as a device to unite these diverse elements.

It is worth making a rough sketch before you start working on a doodle, especially if you plan to include several different items.

Trace your rough sketch onto a fresh sheet of paper and begin doodling! It helps if you start on the main image first: the tree, in this case.

64

Mixed media

Use whatever medium you feel is best suited for each part of the Zen Doodle. Pencil crayon, ballpoint pen, felt-tip pens, fineliners, and gel pens have all been used to produce this design.

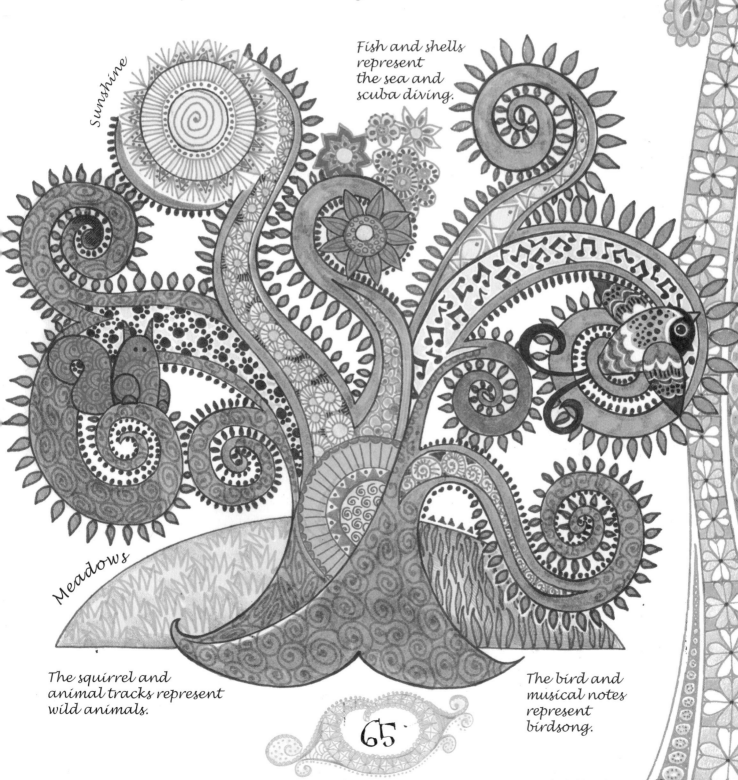

Sunshine

Fish and shells represent the sea and scuba diving.

Meadows

The squirrel and animal tracks represent wild animals.

The bird and musical notes represent birdsong.

Take a line for a walk!

Blind doodling

Close your eyes and, using a pen or pencil, take your line for a walk. Draw a looping, curvy line without taking your hand off the paper. When it feels right, stop and look at what you have drawn.

Nondominant hand

Tip: If you are right-handed, try using your left hand to create the blind doodle and your dominant hand to decorate the design. This can produce even more spontaneous results.

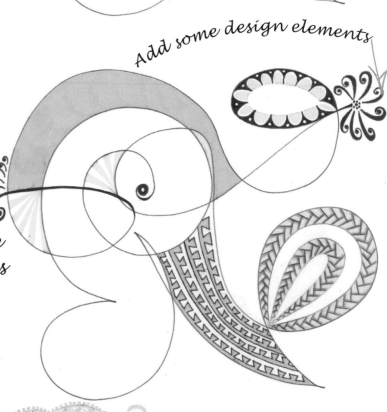

Add some design elements

Color

Choose your color scheme. In this example harmonious, analogous colors—yellow, green, and blue—have been used. Now have fun embellishing your doodle.

66

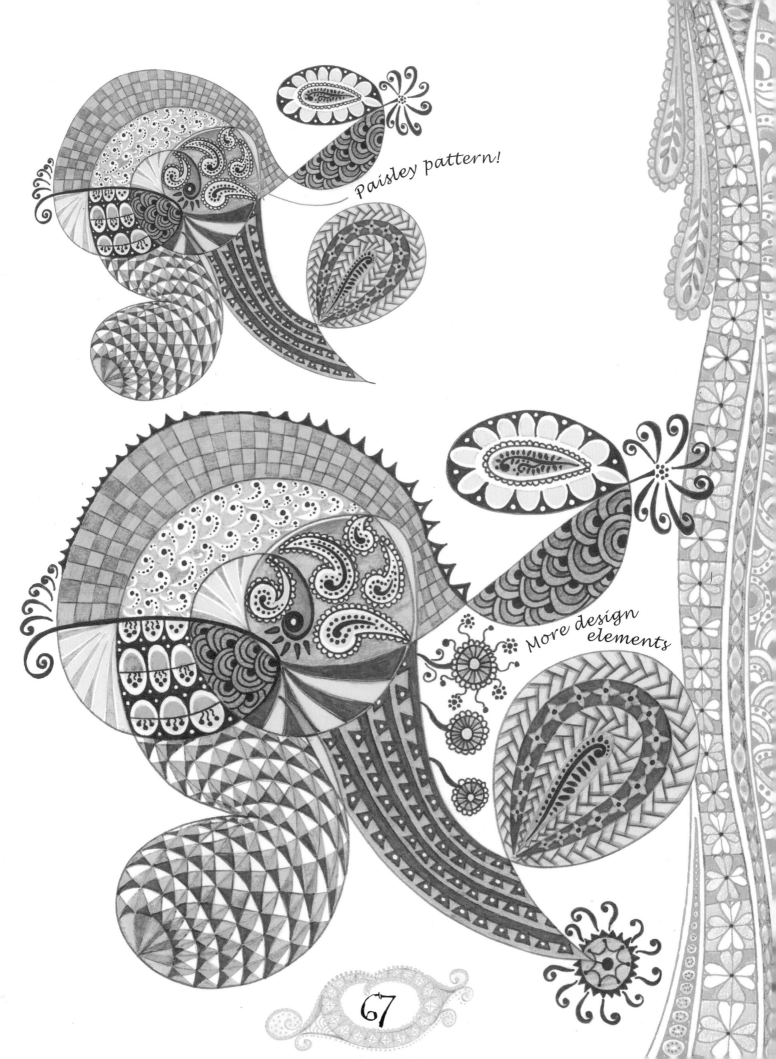

Paisley pattern!

More design elements

Pets

Simplify the Shape

Family pets are a terrific starting point to create an animal-themed doodle. Start by sketching in the animal's basic shape. (You may want to copy or trace a photo.) Then simplify the different shapes that make up the body.

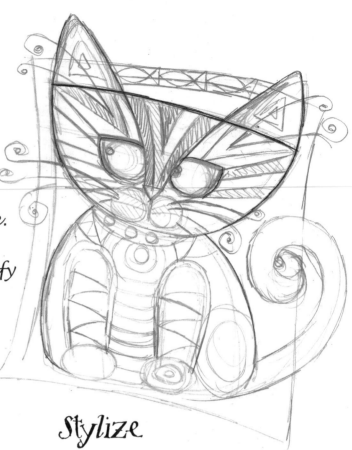

Stylize

In this sketch of a cat (above), the markings on its fur have been stylized to create bold geometric shapes.

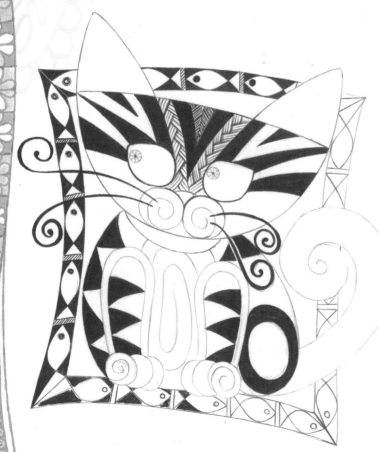

Tonal value

When you are happy with your design, copy or trace it onto a fresh sheet of paper. To re-create the tonal value of the tabby's markings, fill in the dark areas first.

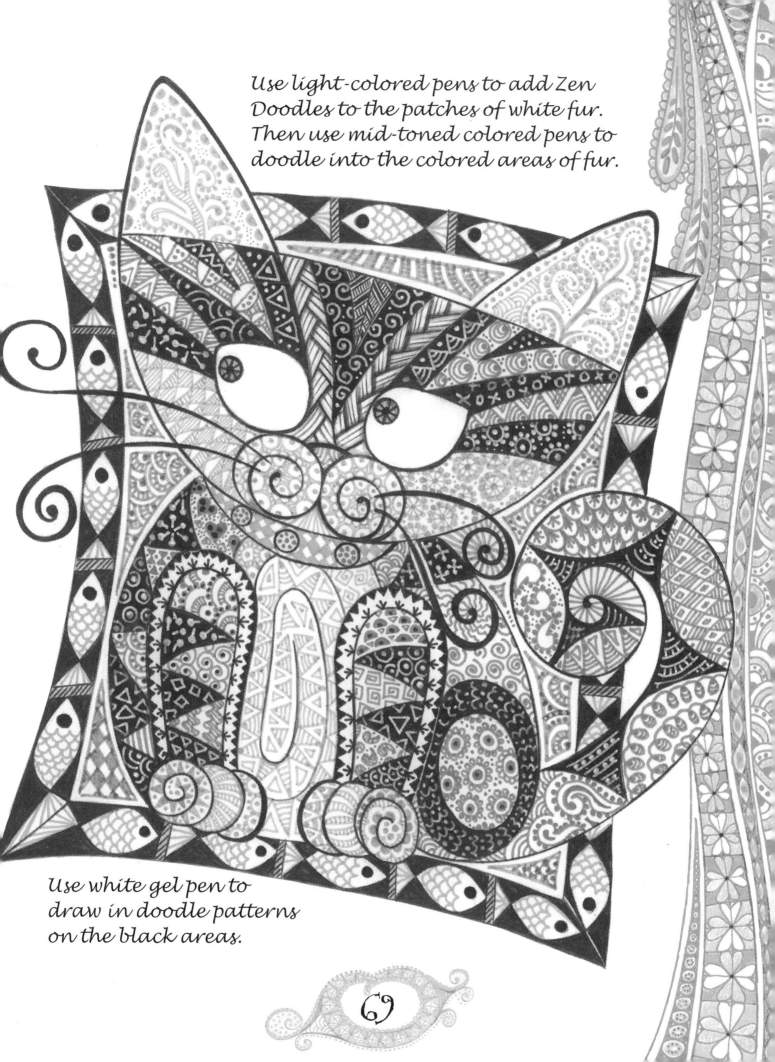

Use light-colored pens to add Zen Doodles to the patches of white fur. Then use mid-toned colored pens to doodle into the colored areas of fur.

Use white gel pen to draw in doodle patterns on the black areas.

69

People doodling 1

Gustav Klimt

Creating incredible Zen Doodles based on people is easy. Before you start, take a look at the work of Gustav Klimt, a pioneer of modern painting. Klimt used ornamental doodling to great effect. He simplified and flattened the shapes of his subject and background, then decorated them with his version of Zen Doodles.

Heads

Sketch in an oval shape. Draw a vertical line through it.

Now draw a horizontal line through the center to position the eyes. Now add a line for the nose.

Female face

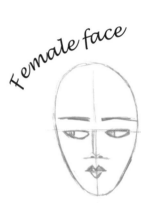

Draw in the eyes and nose. Add eyebrows. Draw in the mouth.

Male face

Male faces (left) are more angular than female faces. Make the chin pointed and the nose stronger. Add a huge moustache and small round glasses.

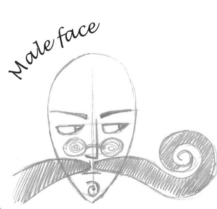

Draw in a semicircle for his shoulders, and crown him with an enormous top hat.

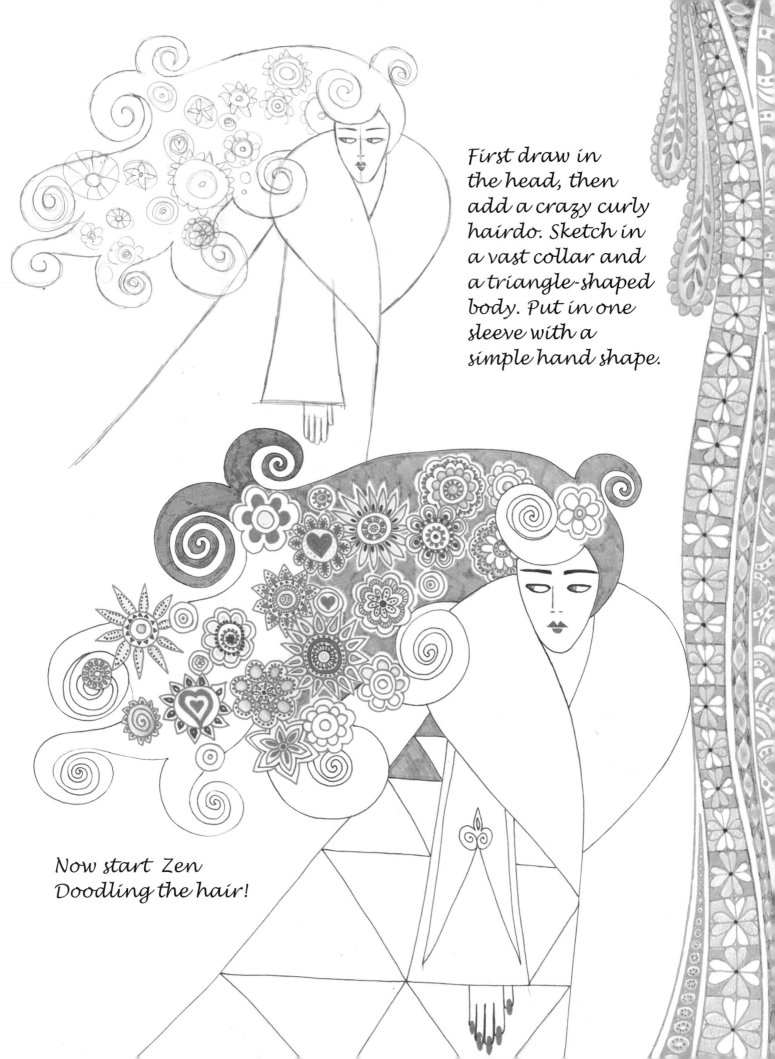

First draw in the head, then add a crazy curly hairdo. Sketch in a vast collar and a triangle-shaped body. Put in one sleeve with a simple hand shape.

Now start Zen Doodling the hair!

People doodling 2
Limited palette

Use a limited palette of colors for a
sophisticated look. The color of the coat
is golden brown alternated with yellow
felt-tip to produce a rich background to
doodle onto. To make the collar stand
out tonally, fill the gaps between the
doodles with dark brown.

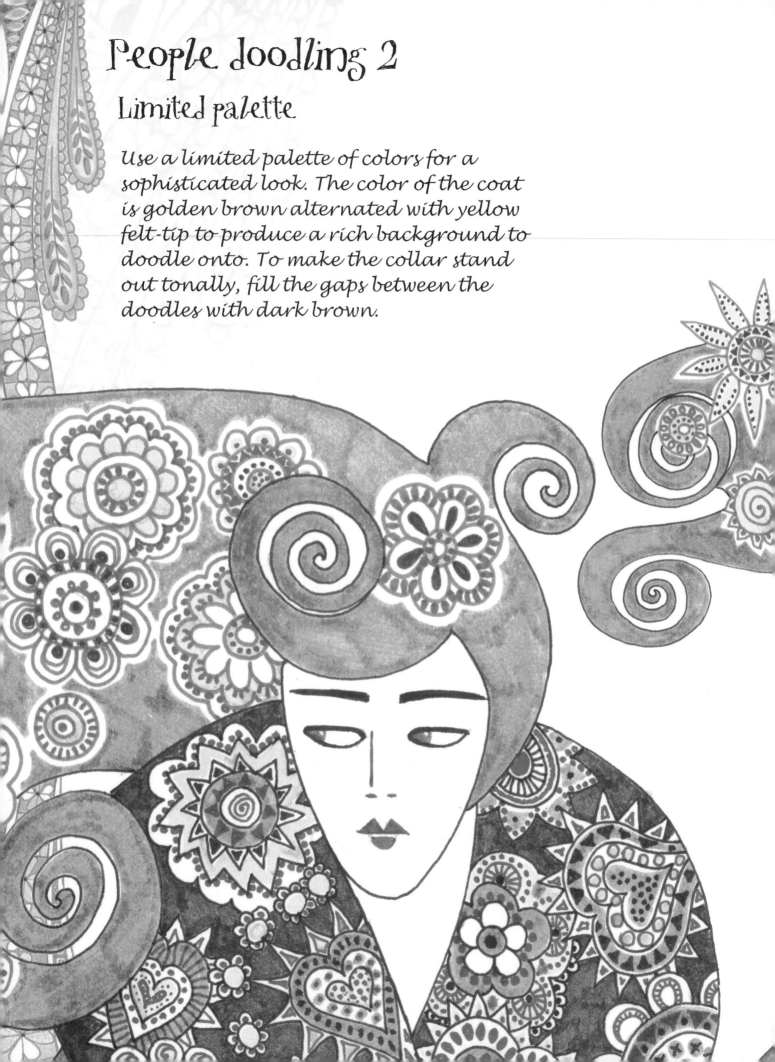

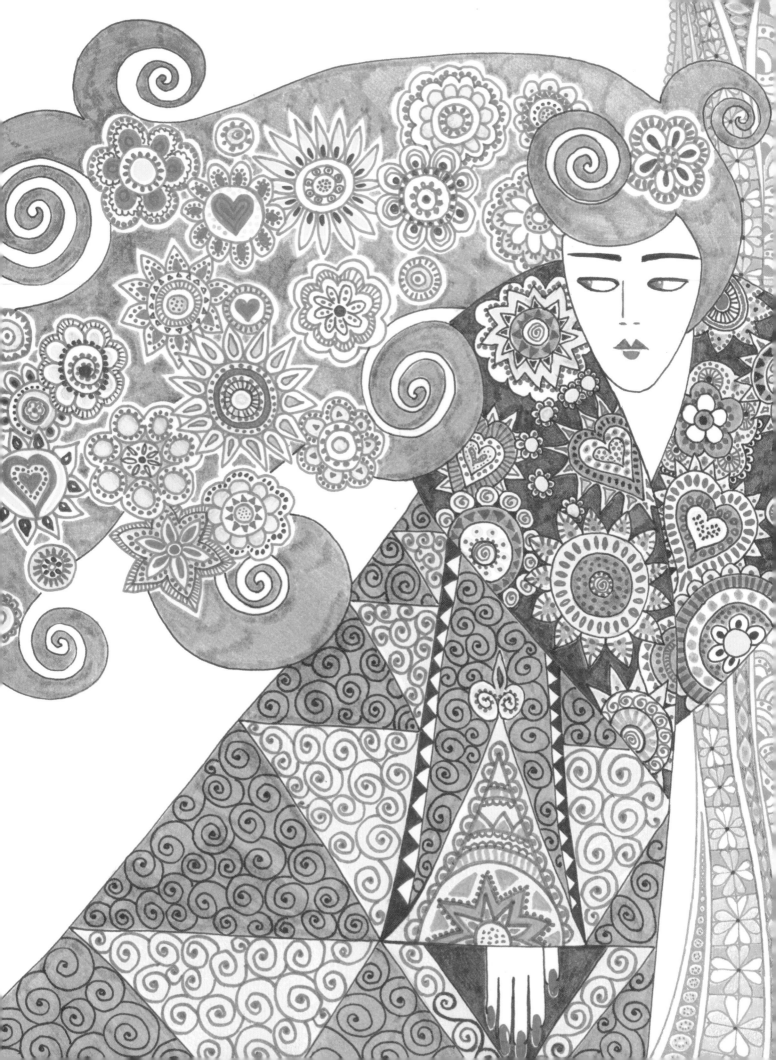

Ancient civilizations

Patterns used by ancient civilizations are very inspiring. Look for potential designs in museums and galleries, and add them to your sketchbook. Use these drawings to inspire themed Zen Doodles like this large ancient Egyptian pattern (right).

Sketchbooks (below) show how patterns have been drawn and then analyzed to learn how to make repeats.

Sketchbooks

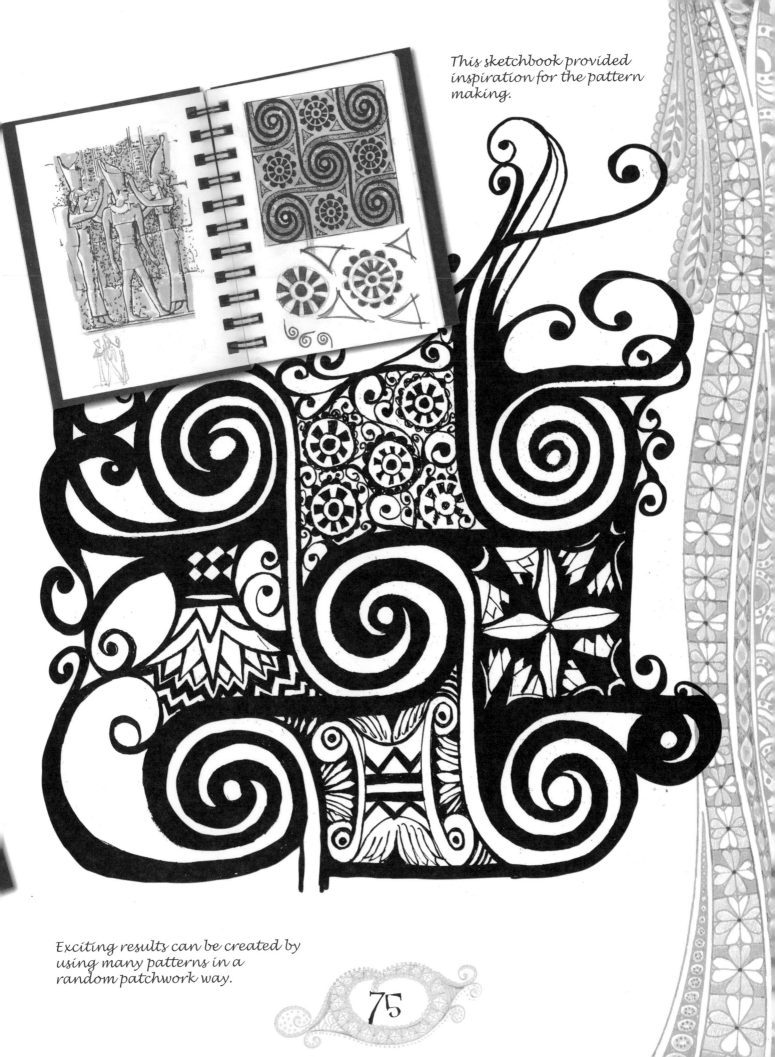

This sketchbook provided inspiration for the pattern making.

Exciting results can be created by using many patterns in a random patchwork way.

Transport inspiration

If you keep working in one particular style and using the same subjects, your work will become less inspired. Try looking at what is around you for inspiration. See the unusual in the everyday.

Car~light designs

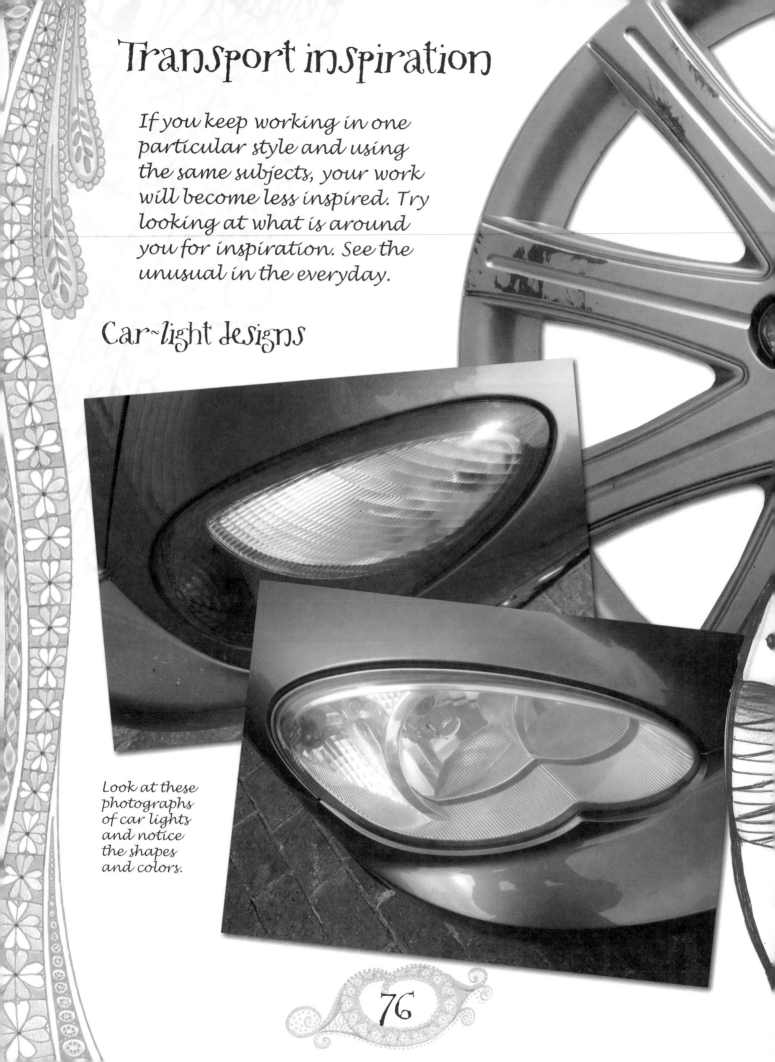

Look at these photographs of car lights and notice the shapes and colors.

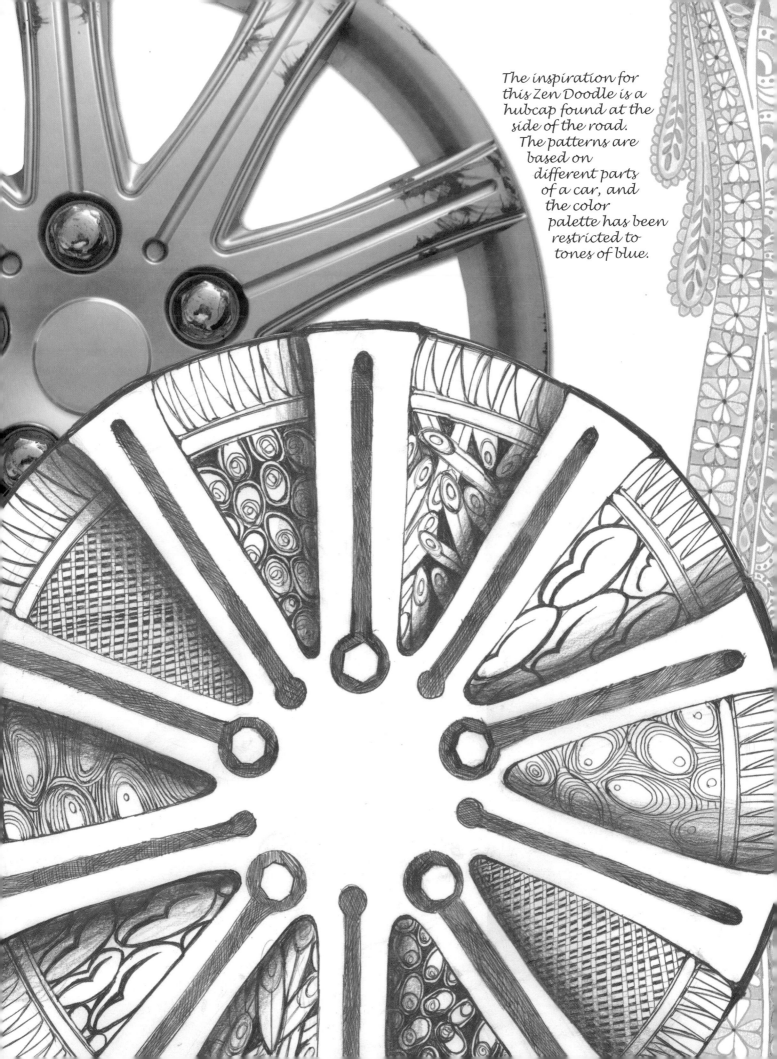

The inspiration for this Zen Doodle is a hubcap found at the side of the road. The patterns are based on different parts of a car, and the color palette has been restricted to tones of blue.

Chapter Four
Experimental techniques

T his book includes only some of the many simple, yet creative, techniques that can be used for Zen Doodling. Let it be a voyage of discovery. Along the way you will build up your versatility and confidence to start experimenting with your own ideas and methods.

All the techniques featured here are fun to do and relaxing. Immerse yourself in doodling and find calmness and contemplation.

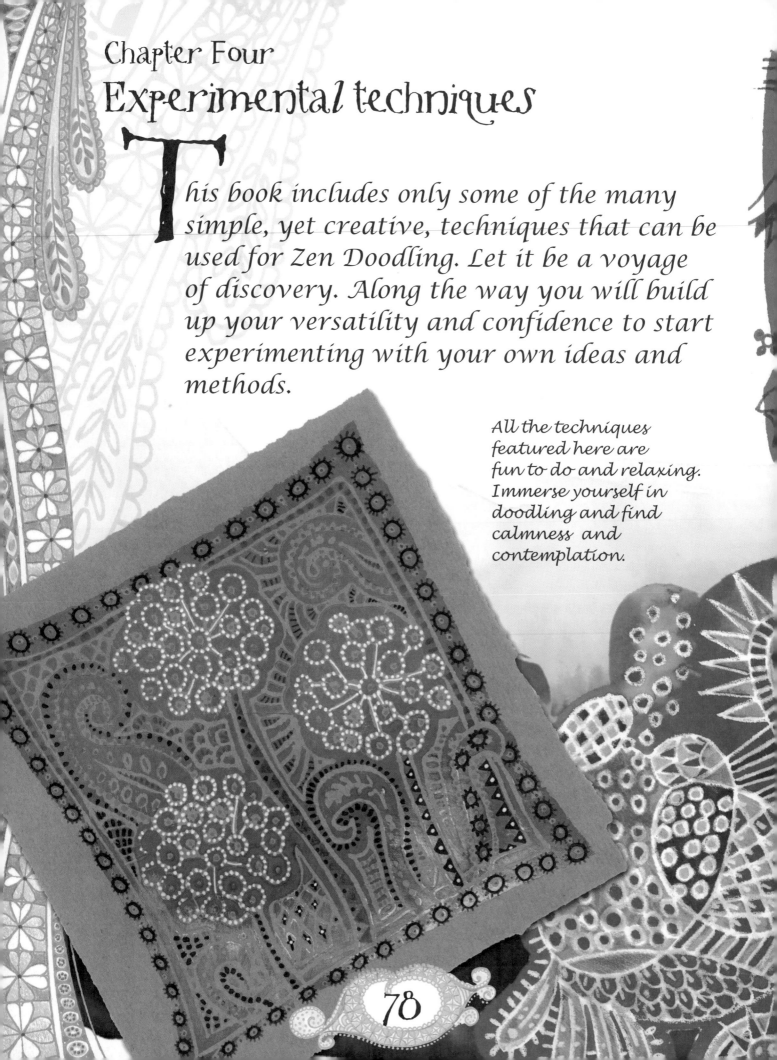

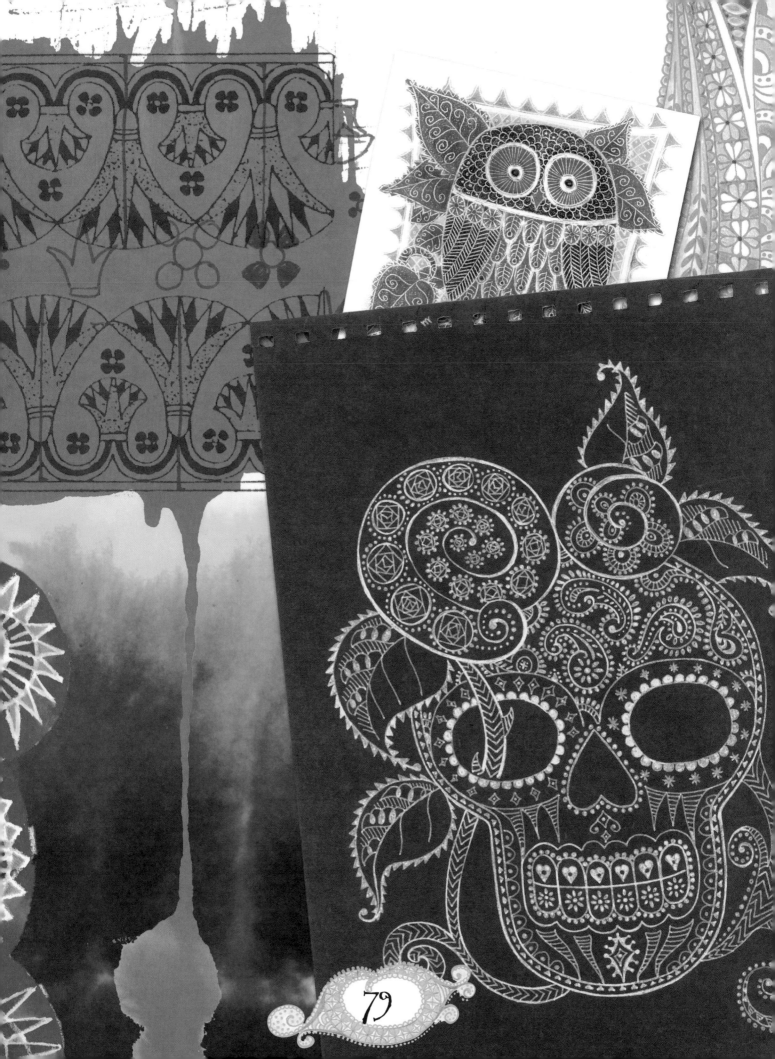

79

Backgrounds

Choosing to work on a background
you have created yourself can be
intimidating. The time and effort
of creating the background can
make you tentative about spoiling
it. Overcome this by creating
batches of background so that
you have "extras" to work on.

This background (below)
was created with a large
brushful of blue ink on
watercolor paper. Let the
paint drip, as random
marks can look exciting.

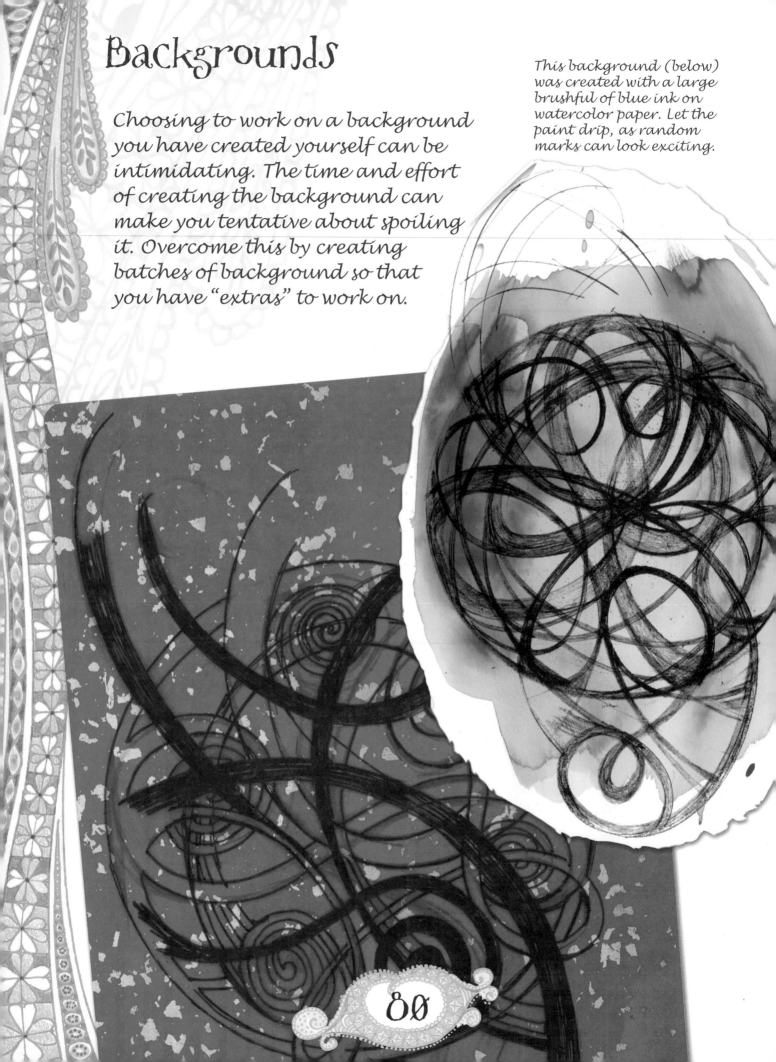

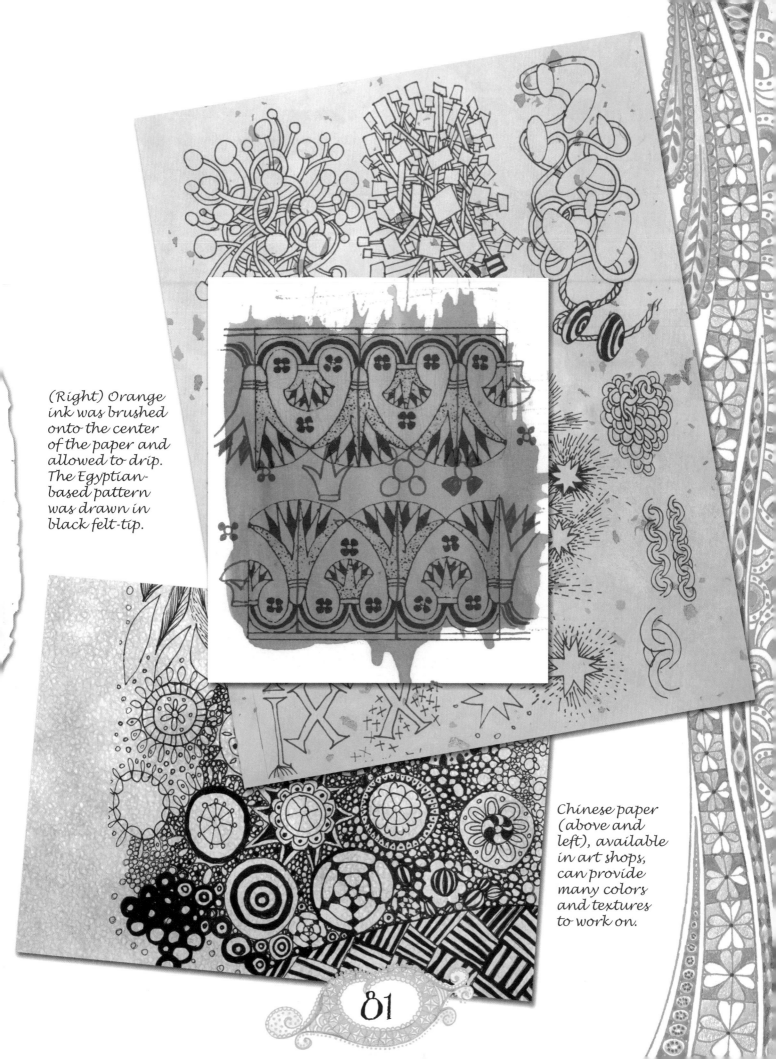

(Right) Orange ink was brushed onto the center of the paper and allowed to drip. The Egyptian-based pattern was drawn in black felt-tip.

Chinese paper (above and left), available in art shops, can provide many colors and textures to work on.

Indenting and resist

Indenting

This very simple yet effective technique produces interesting results. The only materials you will need are a sheet of cartridge paper, a ballpoint pen that has run out of ink, and some soft pencil crayons.

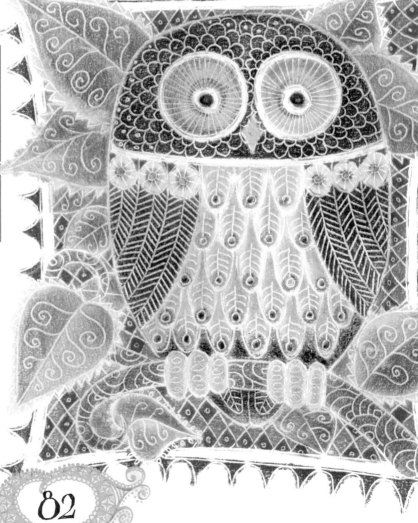

Method

First sketch out your design on some scrap paper. Then lightly trace it onto the cartridge paper. Now start doodling by indenting the paper with the ballpoint pen. Go over the pencil lines, pressing the pen very hard to create an indented pattern.

Once your indented doodle design is complete, color it in with pencil crayons (above). Take care not to press too hard, so that the marks made by the ballpoint pen stay white to make the colors stand out.

82

Resist

Another exciting and easy technique to try is combining white wax crayon with watercolor-based felt-tip pens (and/or watercolor paints). Draw your Zen Doodle onto a sheet of cartridge paper with a white wax crayon. Press firmly as you draw. Then fill in the doodles with felt-tip pens or watercolor. The wax will repel the water in the paint, leaving a white line.

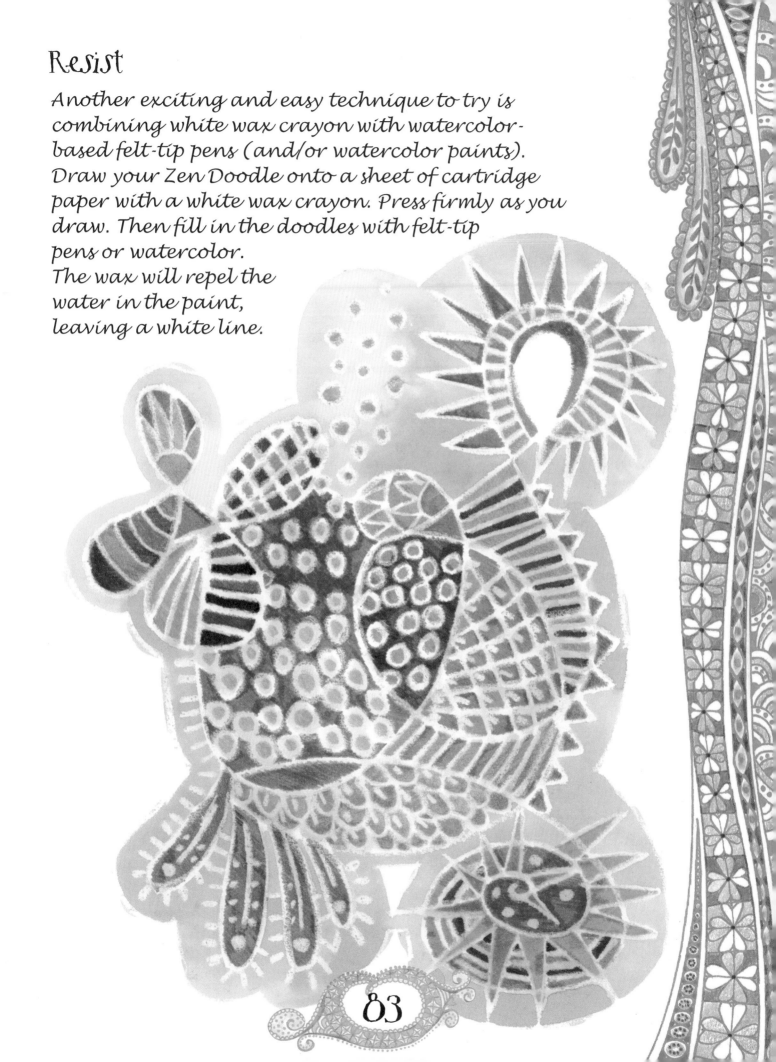

Printmaking

Materials

Clean, shallow polystyrene tray (cut off the raised edges)
Note: Good craft shops sell flat foam sheets for printing, which you may prefer.
Empty ballpoint pen
Tubes of water-soluble block-printing color
Plate for mixing color
Small roller
Sheets of paper

Method

Draw your Zen Doodle onto the polystyrene, pressing firmly with the pen. Mix the color on the tray or plate. Now use the roller to evenly coat the polystyrene printing block with paint. Place the wet block facedown on a sheet of paper and press firmly. Lift the block off, and reink it to make more prints. Wash the block with soap and water when you're finished.

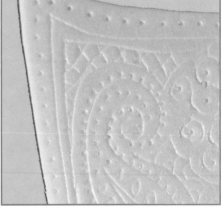

Zen Doodle on polystyrene
(above)

Try printing on different colors and types of paper, for example, tissue or craft papers.

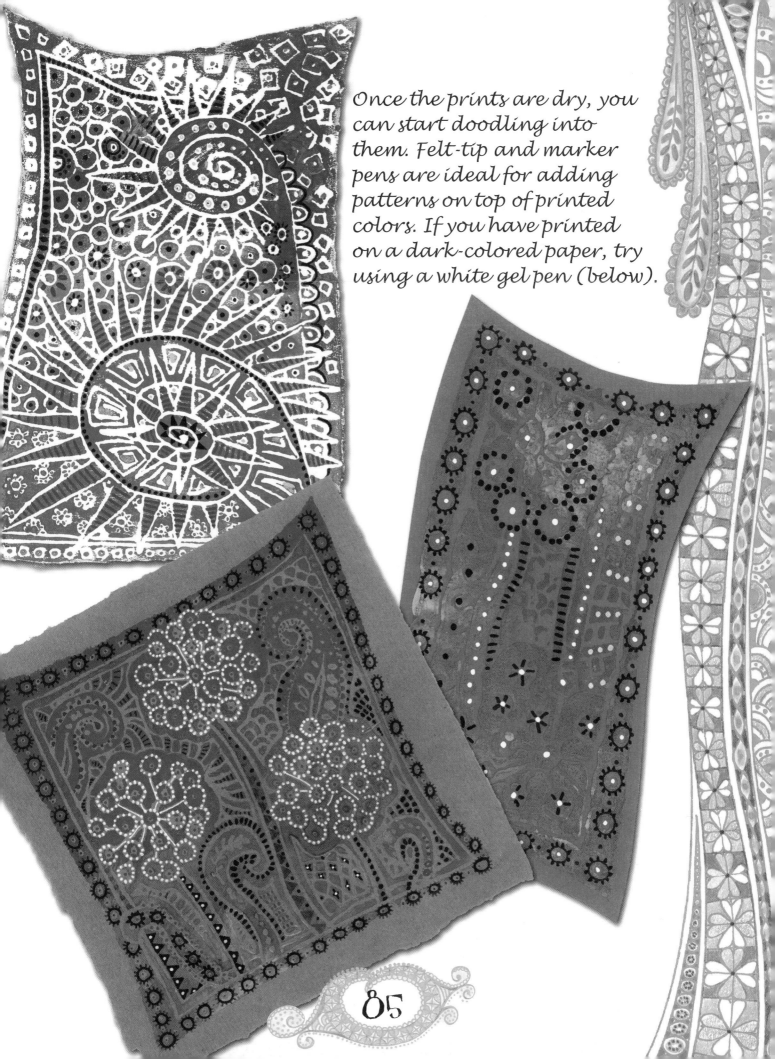

Once the prints are dry, you can start doodling into them. Felt-tip and marker pens are ideal for adding patterns on top of printed colors. If you have printed on a dark-colored paper, try using a white gel pen (below).

85

Metal tray embossing

Working with craft metal and foil is an inexpensive way to make attractive Zen Doodle frames. Sheets of craft metal can be purchased from most art shops, or you can use foil baking trays. You can emboss your design with an empty ballpoint pen or a blunt plastic embossing tool.

When working with metal foil, remember that the edges of the foil can be very sharp!

Method

Sketch out your design on a scrap of paper.

Tape the image to the back of the foil sheet or baking tray. If using a baking tray, the back is the inside of the tray.

With the image facing you, place the foil down onto a towel or another padded surface, like an ironing board.

Trace over the design using an embossing tool or an empty ballpoint pen. Craft foil is usually thinner than foil baking trays.

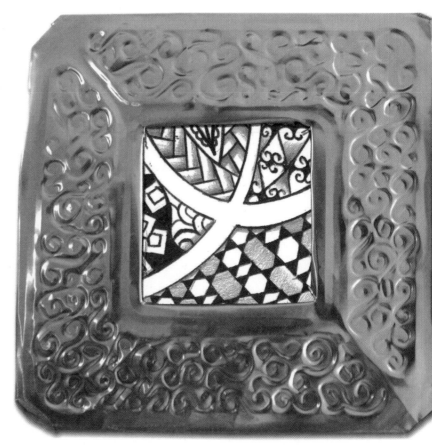

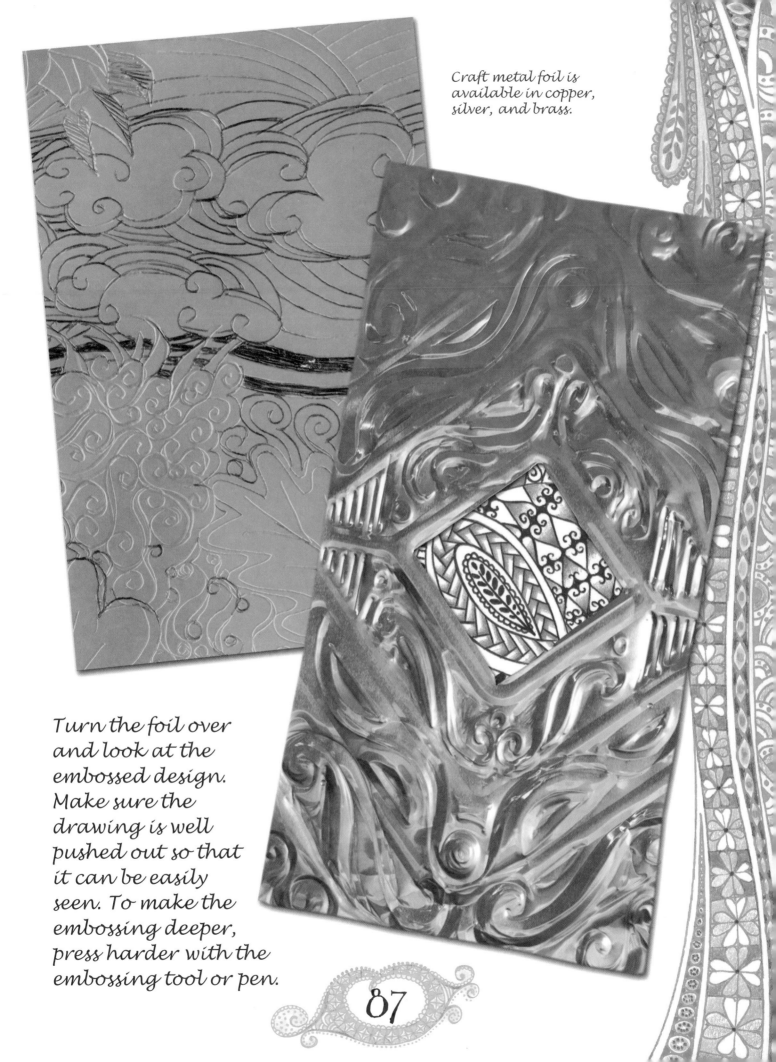

Craft metal foil is available in copper, silver, and brass.

Turn the foil over and look at the embossed design. Make sure the drawing is well pushed out so that it can be easily seen. To make the embossing deeper, press harder with the embossing tool or pen.

Copying and enlarging

A grid can be used to help you accurately copy and enlarge your Zen Doodle. Dividing a drawing into small gridded sections makes it much easier to copy.

First divide your original Zen Doodle using a grid. Choose a grid size that is good for the drawing and that you feel comfortable with.

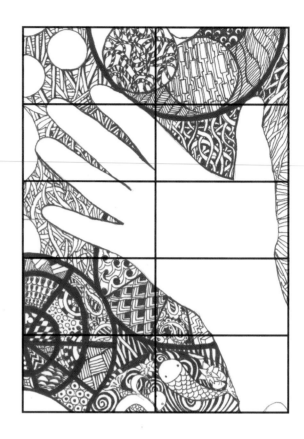

Now you can see your doodle as separate sections. This makes it easier for you to keep each section proportionally the same when you enlarge it.

You may even discover that you particularly like certain sections and want to use them in a new drawing!

Draw a proportionally larger grid,
and then copy and enlarge each
section individually.

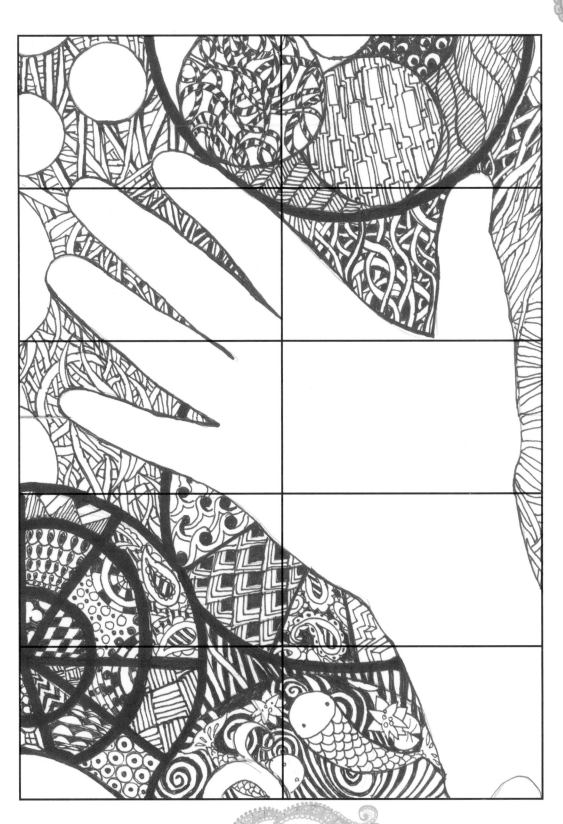

Posters

Don't feel daunted at the idea of working on a large scale; it can be very liberating! Start by making a thumbnail sketch of the main design, then square it up and trace it onto a large sheet of paper. Now relax! Where possible, use bold, sweeping lines. Enjoy doodling!

Equipment

Thick felt-tip pens are best for putting in any bolder elements, adding contrast and interest to the texture of your doodles. Take time to step back from your artwork to check how it looks from a distance. You may want to adjust some tonal values.

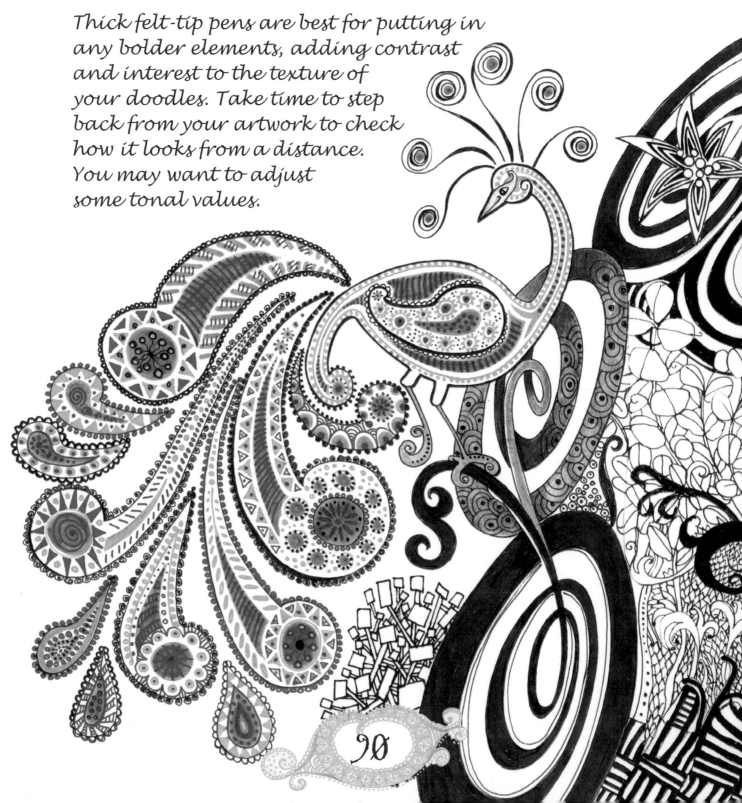

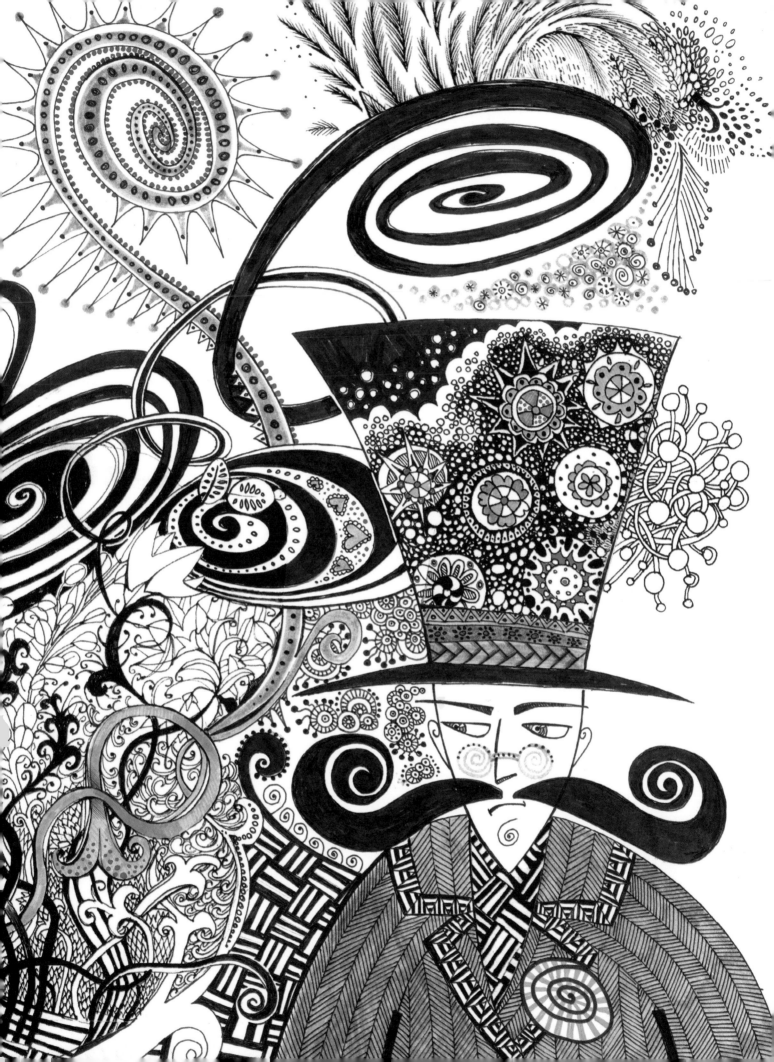

Pattern builders

It is helpful to create your own library of patterns to fall back on to inspire your Zen Doodles. Luggage labels are a cheap and easy way to store your patterns. Draw on both sides of each label, and keep your patterns together on a key ring. You will quickly build up a good selection.

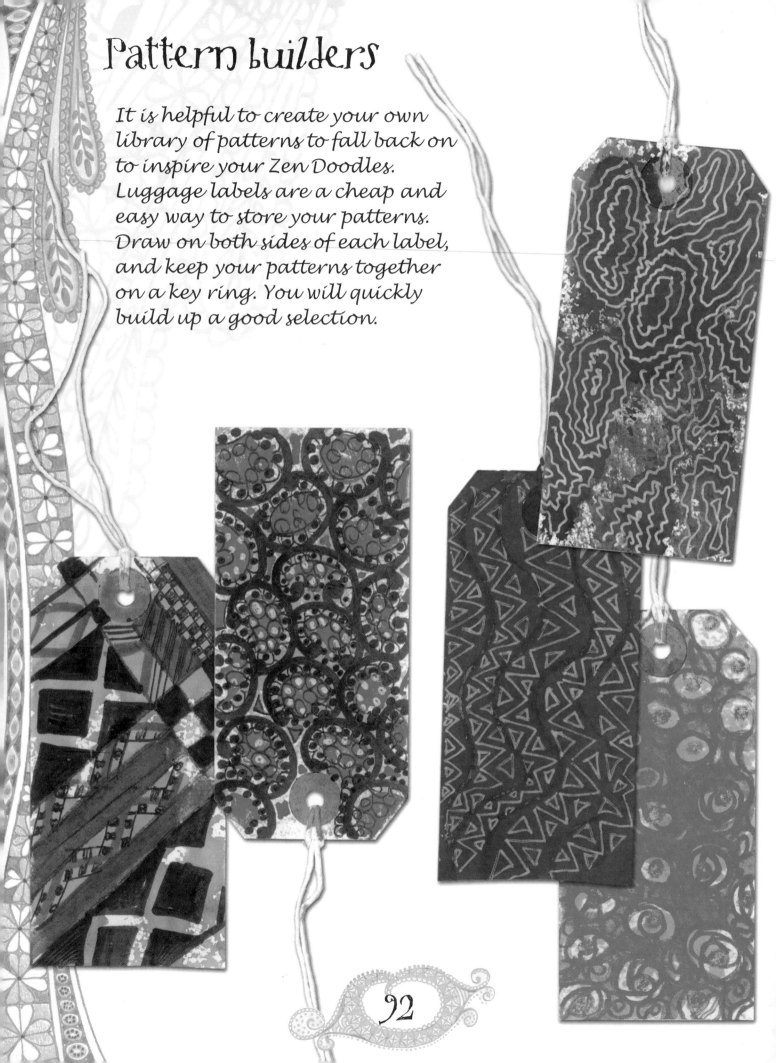

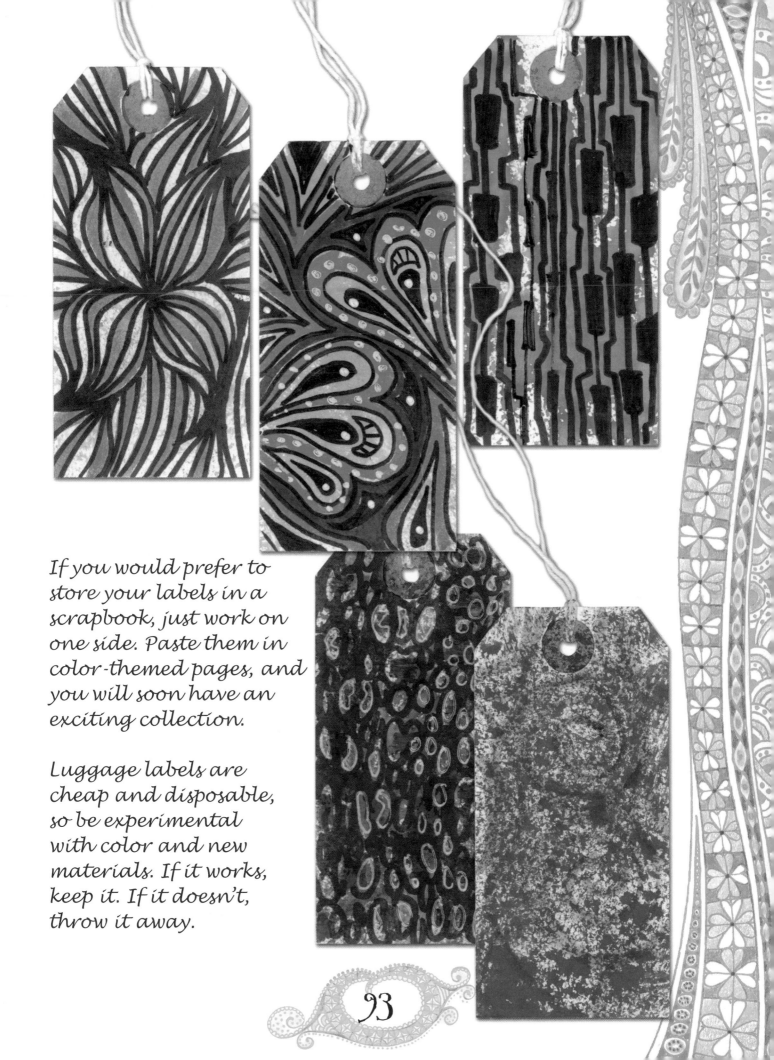

If you would prefer to store your labels in a scrapbook, just work on one side. Paste them in color-themed pages, and you will soon have an exciting collection.

Luggage labels are cheap and disposable, so be experimental with color and new materials. If it works, keep it. If it doesn't, throw it away.

Collage

Collage is an effective and fun way to embellish your Zen Doodles. Add elements such as sequins, glitter, lace, ribbon, string, leaves, and feathers to highlight areas of your design.

Anything goes!

Collect things you find visually exciting such as scraps of paper with interesting textures and patterns, beads, shells, photographs, pieces of fabric. These can either become fabulous sources of inspiration for Zen Doodles or be used to create doodles with collage.

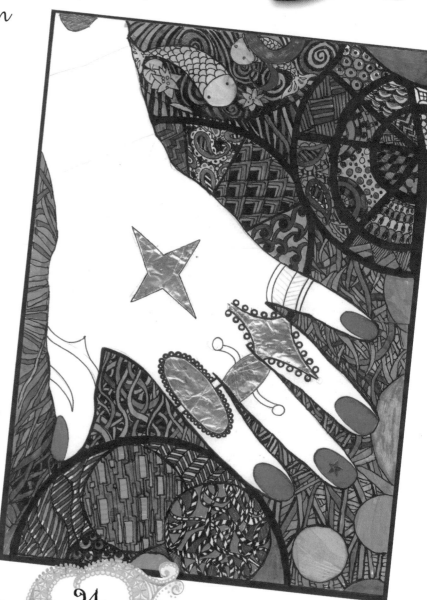

In this example, aluminum foil was used for the jewelry, along with stick-on gems and sequins. Additional gems, wool, and a scrap of lace were added to enhance the background.

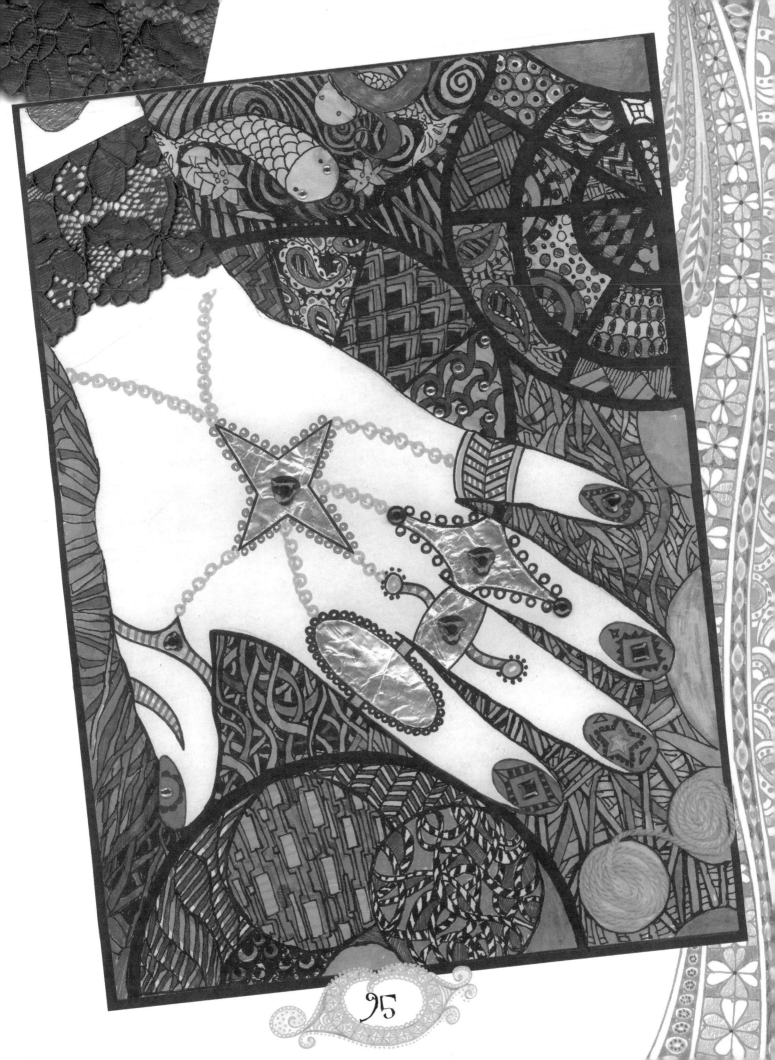

95

Patterns

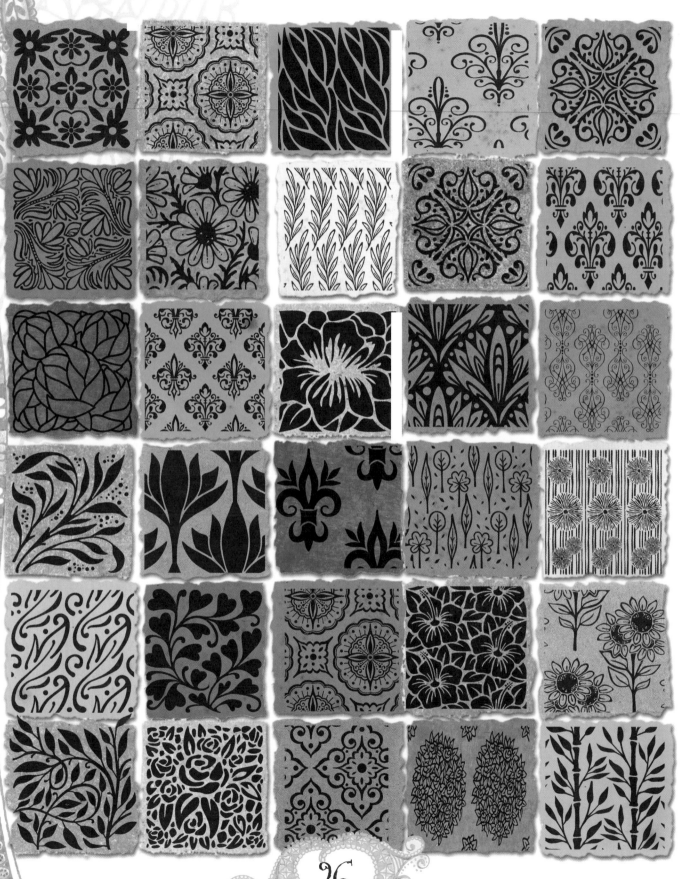

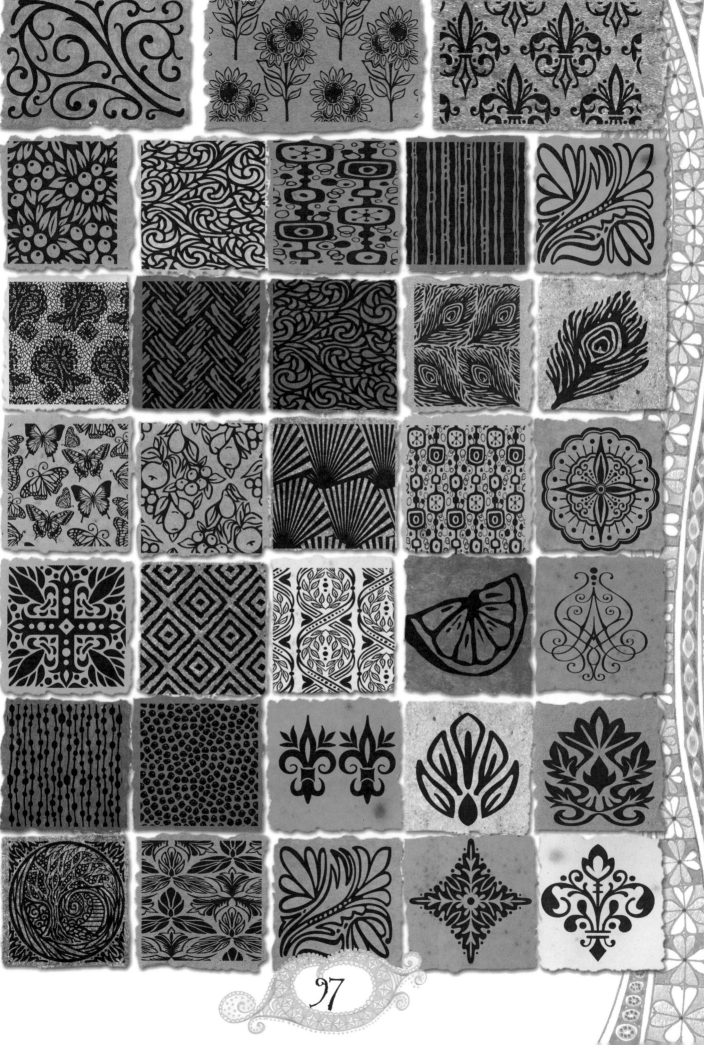

White on black

Eternity

The skull makes a powerful image: it can represent death, danger, power, protection, or strength. When combined with a rose, it can symbolize eternity or resurrection.

Start by drawing a simple skull shape using an oval, then add a semicircle for the lower jaw. Add ovals for the eye sockets, a heart-shaped nose, and some teeth.

Draw in circles for the roses, then add stems and leaves. It's more effective if you let the flowers entwine with the skull.

Trace your sketch onto black paper. Using a white gel pen, draw in the main shapes, and you are ready to start Zen Doodling!

98

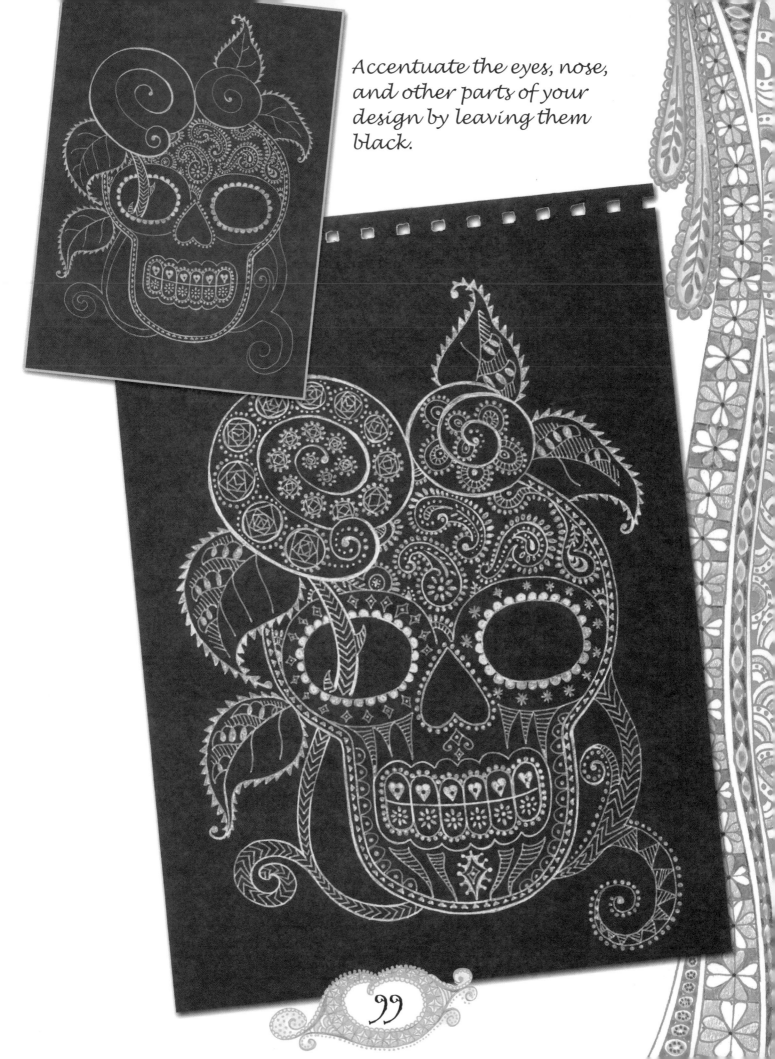

Accentuate the eyes, nose, and other parts of your design by leaving them black.

99

Hands

Hands have often appeared in art since early man created the first known cave paintings. According to each culture the image of a hand has different meanings. In Buddhism it can symbolize inherent energy such as meditation, receptivity, unity, and wisdom.

Draw around your own hand. Now draw in a frame so that it comes in front of the wrist and behind the fingers.

Then start Zen Doodling! Begin by doodling the frame, then progress onto the hand itself.

Make copies

Make some photocopies of your completed black and white Zen Doodle. Then color them in using different color schemes—try coloring each one using a different medium.

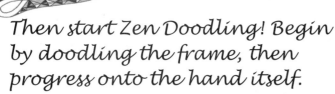

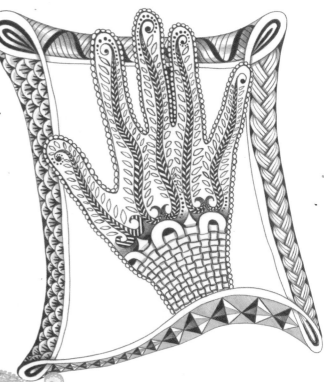

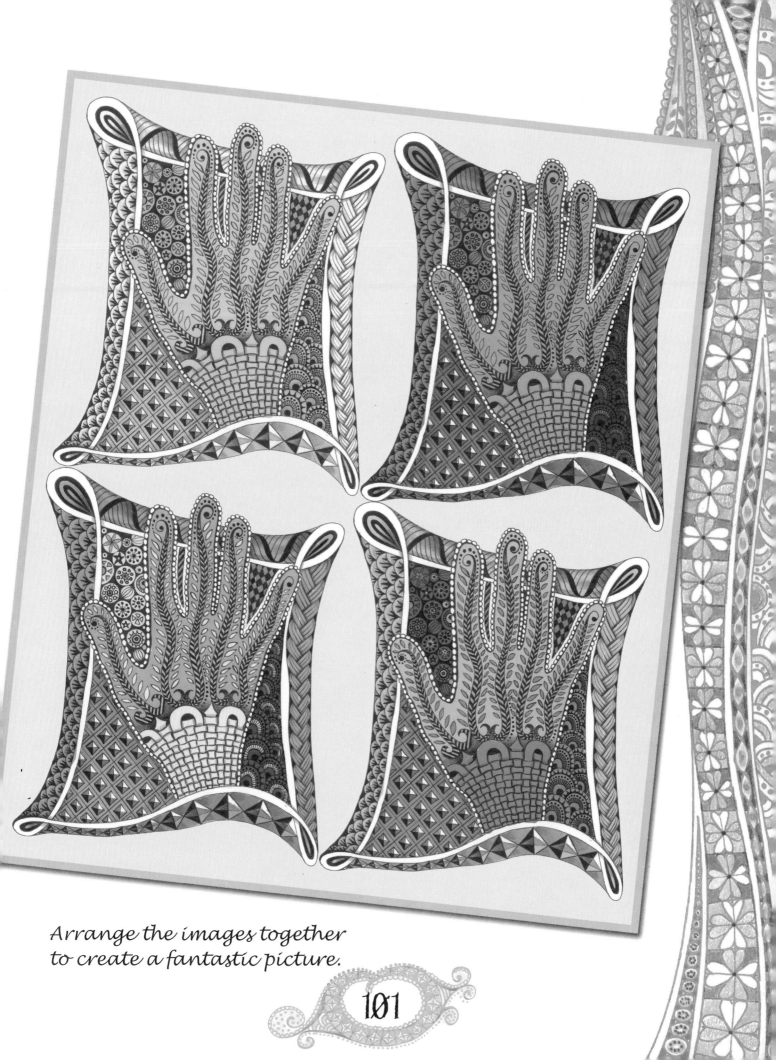

Arrange the images together
to create a fantastic picture.

101

Chapter Five
Using Zen Doodles

Zen Doodling is an extremely versatile form of decoration. Its potential is limitless. You just have to make sure that all surfaces you want to doodle on are suitable and that you have the correct tools for the job!

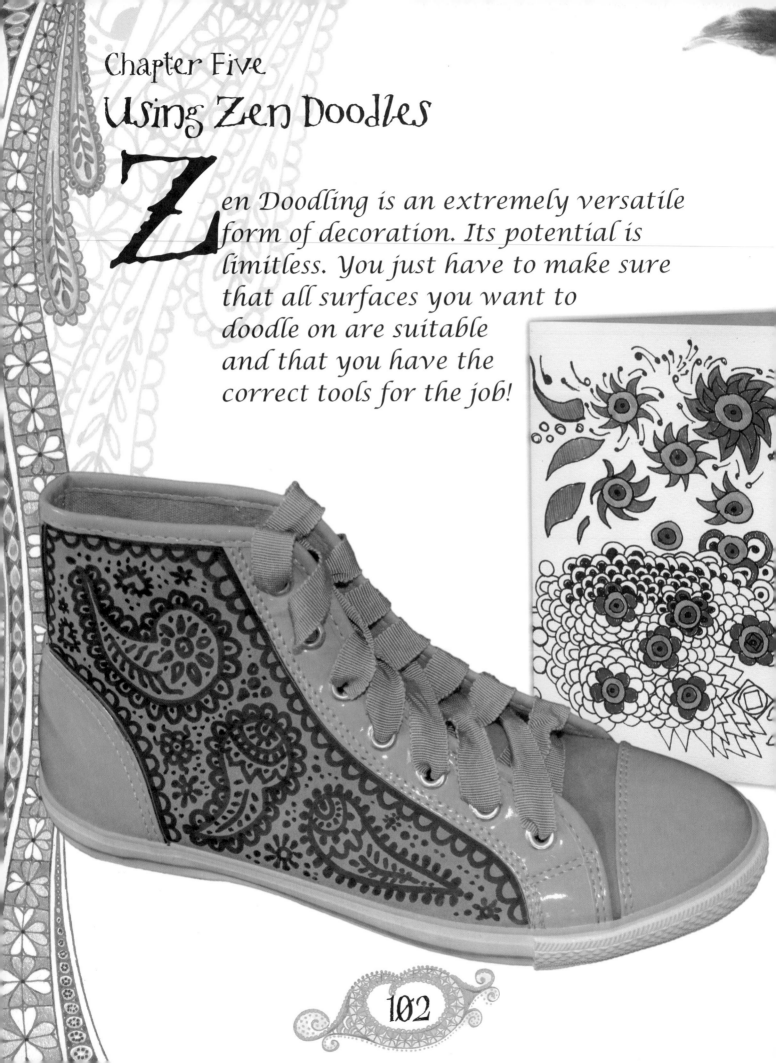

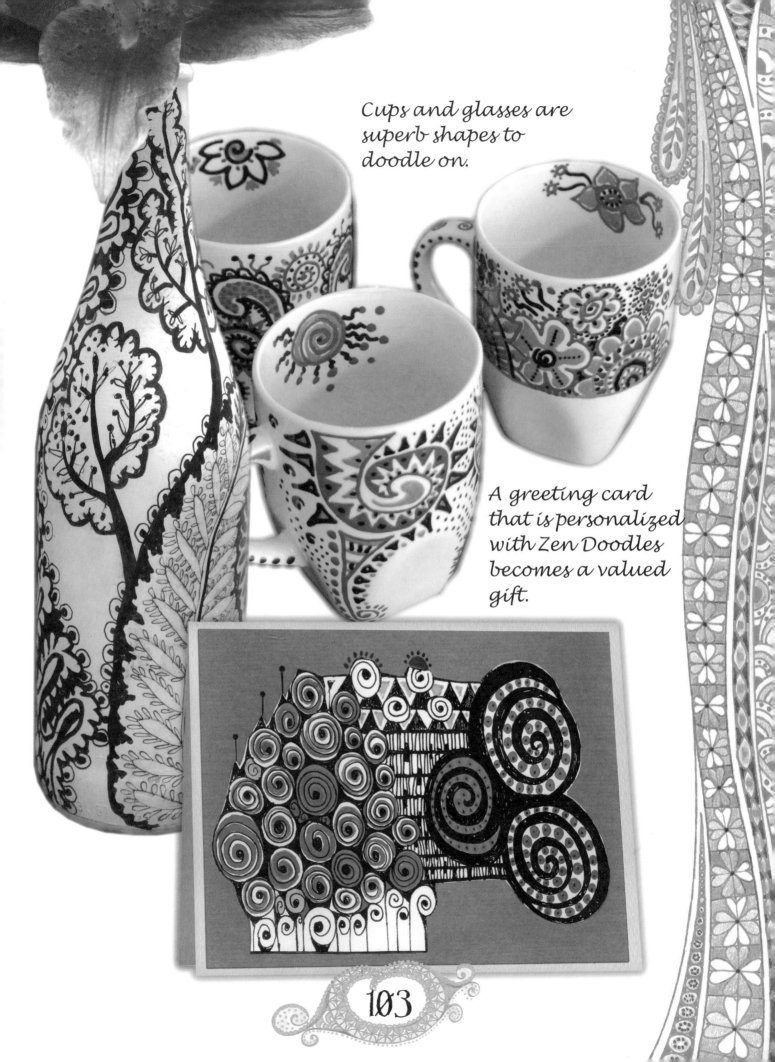

Cups and glasses are superb shapes to doodle on.

A greeting card that is personalized with Zen Doodles becomes a valued gift.

103

Greeting cards

Friends and family always delight in receiving personalized greeting cards. You may find that your doodles are not only treasured and collected but even framed! Creating your own handmade cards is a great way to save money, and you will have great fun at the same time.

Personalized

To make a personalized card for someone, focus your mind on that person, and think about their unique qualities while you create your Zen Doodles.

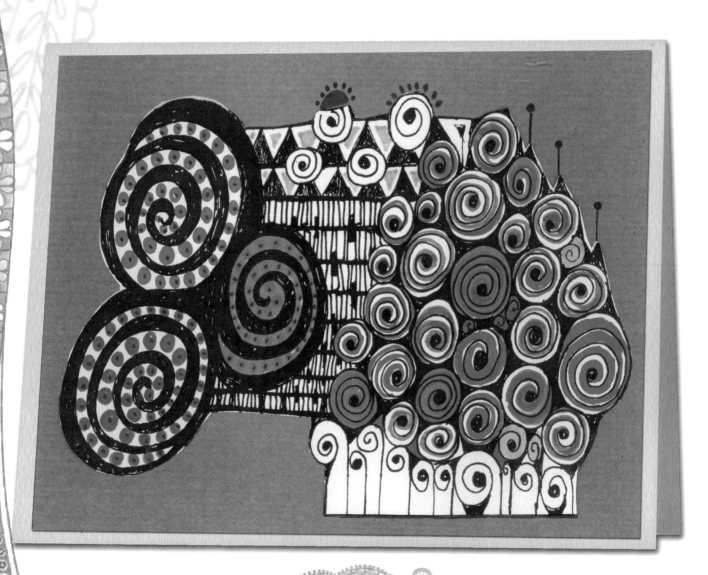

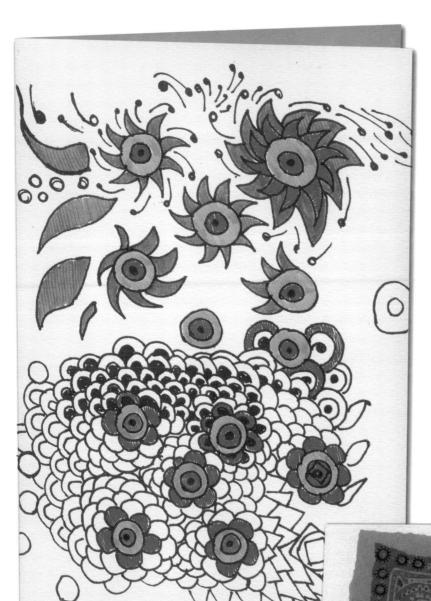

Don't forget to write "Handmade by... [insert your name]" on the back of your cards. This creates a personal touch.

Tip: Make sure your card fits your envelope before you start your Zen Doodle!

Create sets of cards by using the printing technique on pages 84-85. Decorate each print with different doodles to make them unique.

A ragged edge on your prints creates a more handmade look.

3~D Zen Doodling

Pebbles

Decorating and embellishing different 3-D shapes and surfaces is very rewarding, particularly working on pebbles, since their organic shape complements the flowing lines of Zen Doodling.

Method

Start by collecting some pebbles from a beach, river, or garden, then wash and dry them. Smooth, light-colored pebbles are most suitable.

Hold the pebble in your hand and study its shape and feel to help you decide what patterns to use. You may be inspired to doodle it into an animal design or simply want to decorate it with some repeating patterns.

Use different thicknesses of black marker pen to cover your pebbles with patterns. A white gel pen is ideal for adding contrast.

Note: If you want to paint the pebbles white, first apply one or two coats of acrylic paint.

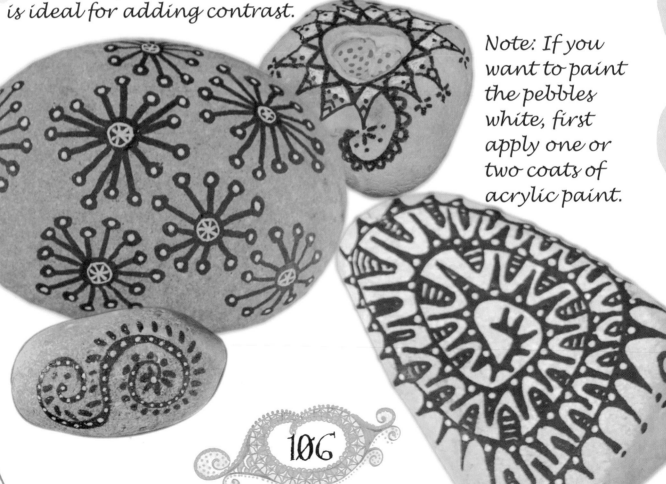

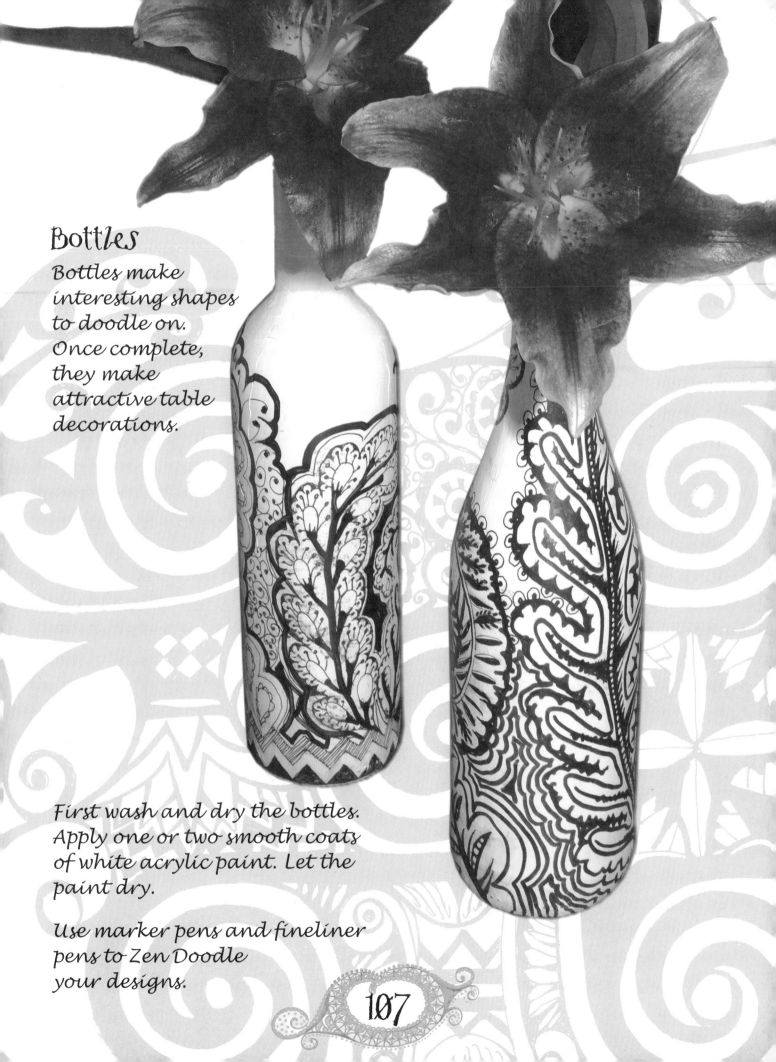

Bottles

Bottles make interesting shapes to doodle on. Once complete, they make attractive table decorations.

First wash and dry the bottles. Apply one or two smooth coats of white acrylic paint. Let the paint dry.

Use marker pens and fineliner pens to Zen Doodle your designs.

107

Keeping a journal

A journal is where you can write down your ideas, goals, thoughts, dreams, and fears—in fact anything that may reflect your being. Keeping a journal can give you personal insight and an opportunity to develop by examining your life.

Zen Doodle each day!

Set aside a regular time each day to work on your journal. Write whatever is in your mind, and as you relax, start doodling!

Tip: Some pens are particularly nice for writing and drawing. If you have a favorite pen, keep it beside your journal!

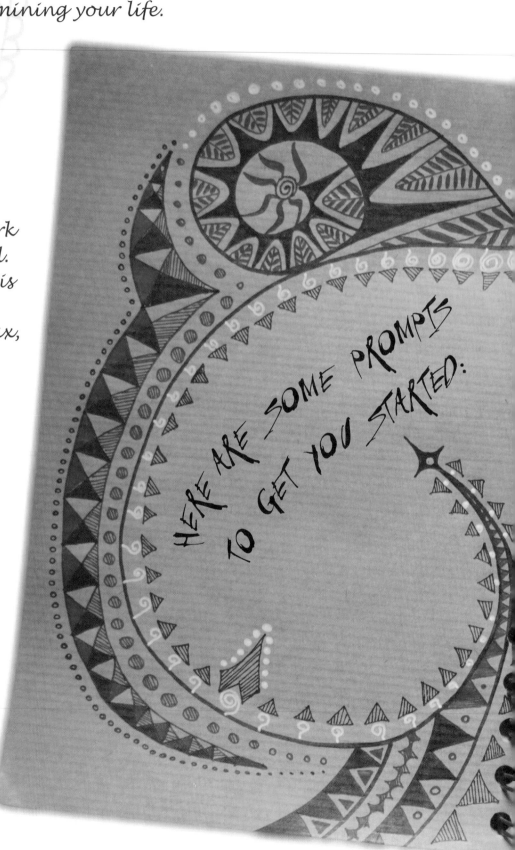

HERE ARE SOME PROMPTS TO GET YOU STARTED:

Portable

A journal can be a spiral notebook or a small sketch pad—whatever you prefer, as long as it's portable. Journals are the ideal place for Zen Doodling, too. Simply doodle into the written pages when an idea occurs to you. The finished result will not only be decorative, but it will also provide a meaningful record of your feelings.

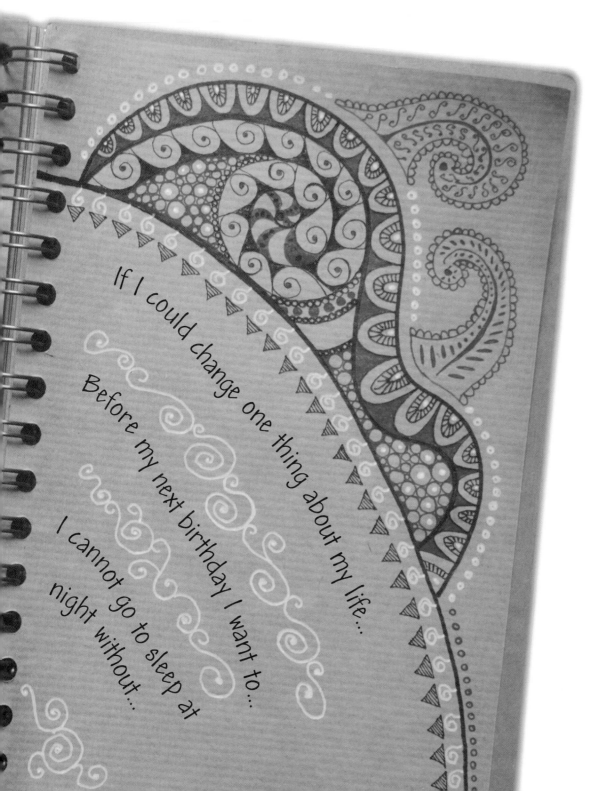

If I could change one thing about my life...

Before my next birthday I want to...

I cannot go to sleep at night without...

Glass and china

It is great fun and also very satisfying to decorate pieces of glass and china with your doodles. Turn secondhand china or cheap or plain pieces into fantastic, personalized works of art!

Porcelain pens

You can purchase pens to paint on porcelain from any good craft shop (most brands work on both china and glass). They are very easy to use. Simply draw on your design, then let it air-dry. Some makes of pen require the art be baked in a conventional oven for a short time to ensure the paint is dishwasher-safe.

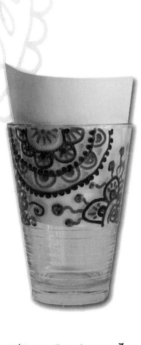

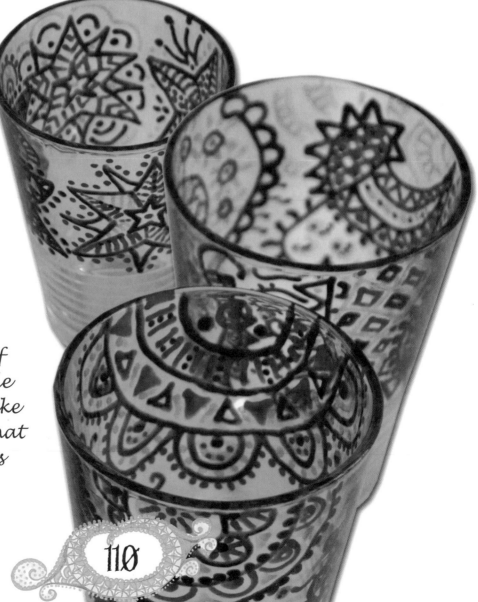

Tip: Put a sheet of white paper inside clear glass to make it easier to see what your doodle looks like (above).

It is helpful to do rough drawings of the various doodles you plan to use before starting work directly onto the china or glassware. Try to use Zen Doodle designs that complement the shape or angles of the piece you are decorating.

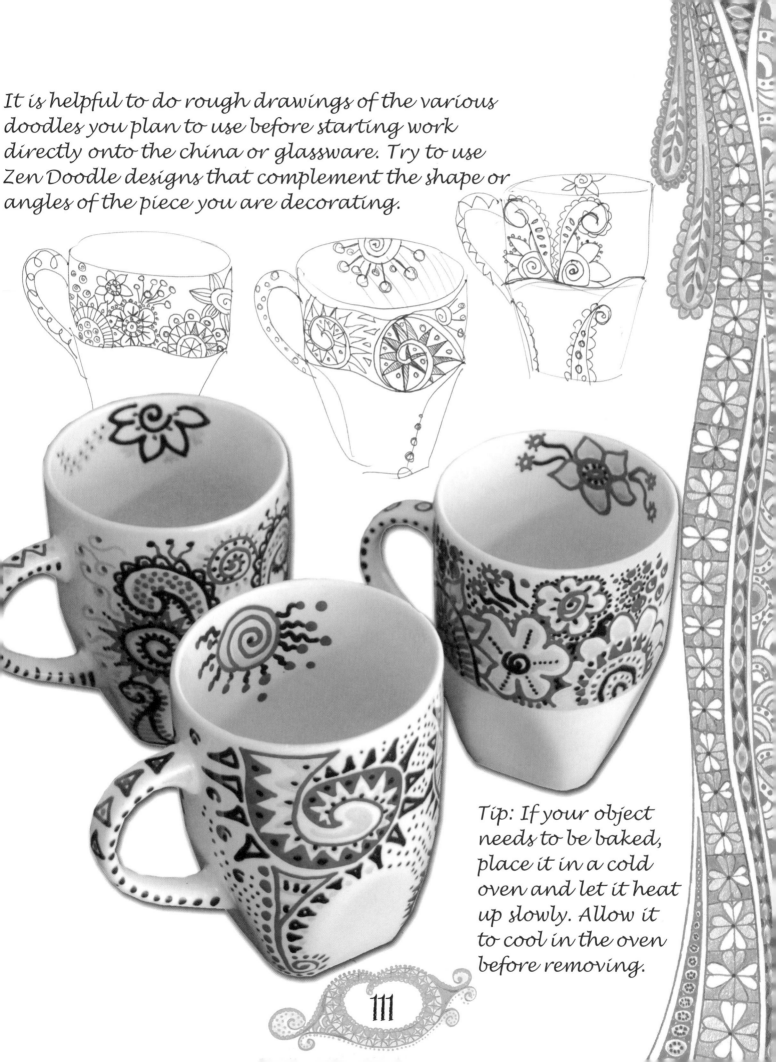

Tip: If your object needs to be baked, place it in a cold oven and let it heat up slowly. Allow it to cool in the oven before removing.

Zen Doodling shoes

Make a bold fashion statement with your own unique Zen Doodled shoes!

Canvas

All the shoes and boots shown here are made of canvas. Draw on your doodle patterns using permanent fabric-marker pens (available from all good craft shops).

Do some sketches of the shoes first to try out your doodling ideas. Keep the main shapes of the design symmetrical: shoes can have different patterns, but they must look like a matching pair.

Tip: Remove the shoelaces before you start doodling.

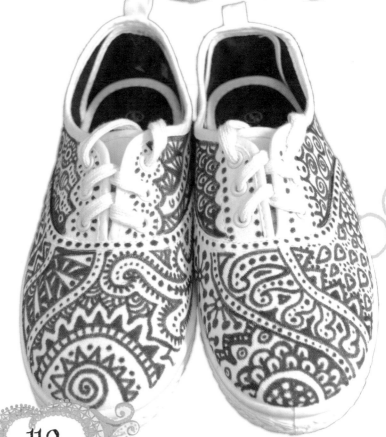

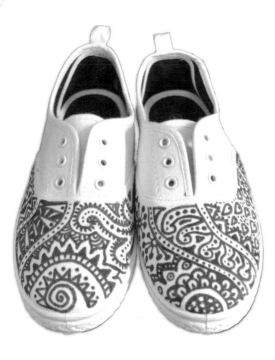

You may decide to leave parts of the shoes white.

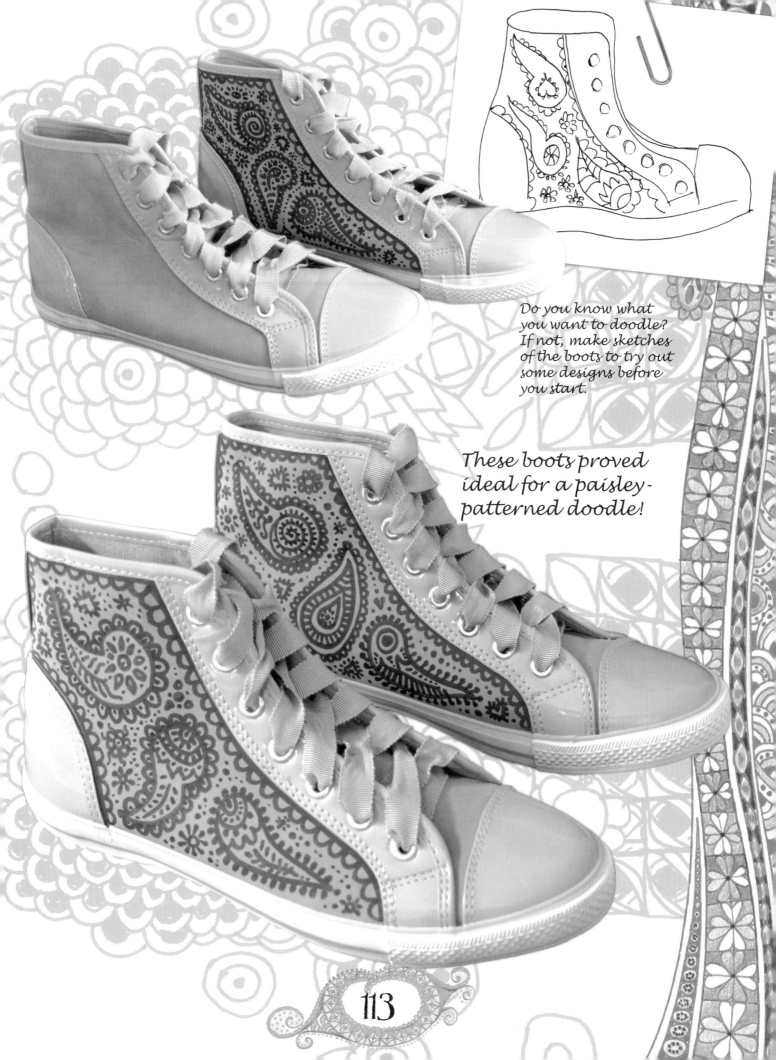

Do you know what you want to doodle? If not, make sketches of the boots to try out some designs before you start.

These boots proved ideal for a paisley-patterned doodle!

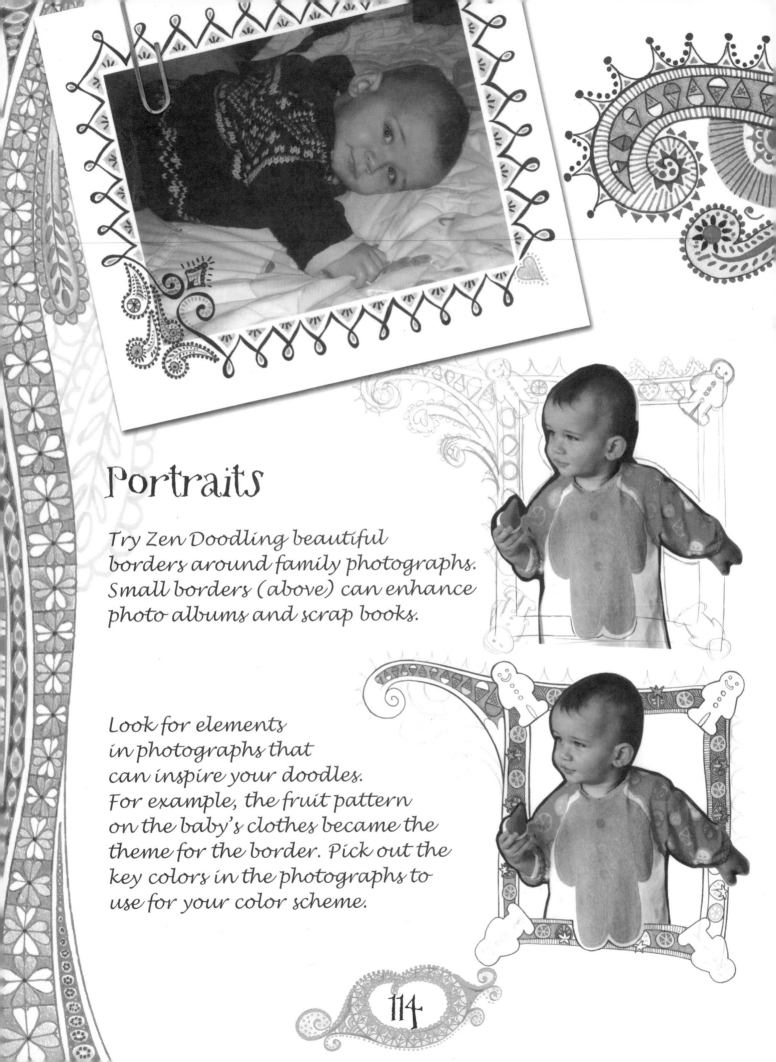

Portraits

Try Zen Doodling beautiful borders around family photographs. Small borders (above) can enhance photo albums and scrap books.

Look for elements in photographs that can inspire your doodles. For example, the fruit pattern on the baby's clothes became the theme for the border. Pick out the key colors in the photographs to use for your color scheme.

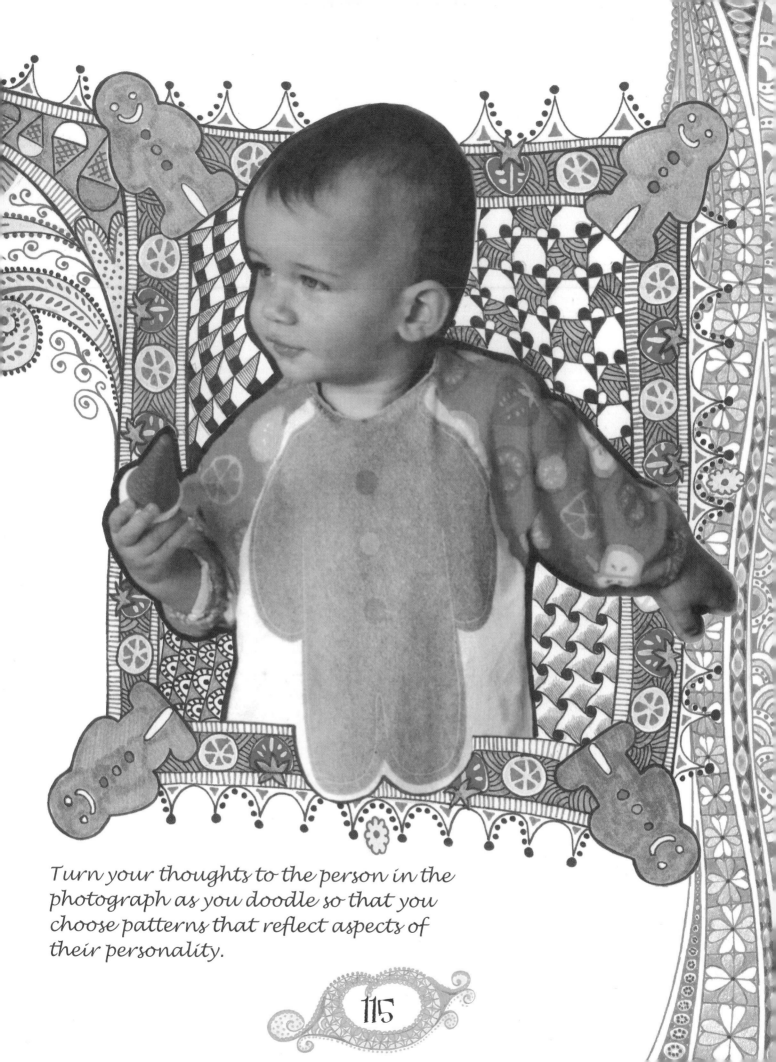

Turn your thoughts to the person in the photograph as you doodle so that you choose patterns that reflect aspects of their personality.

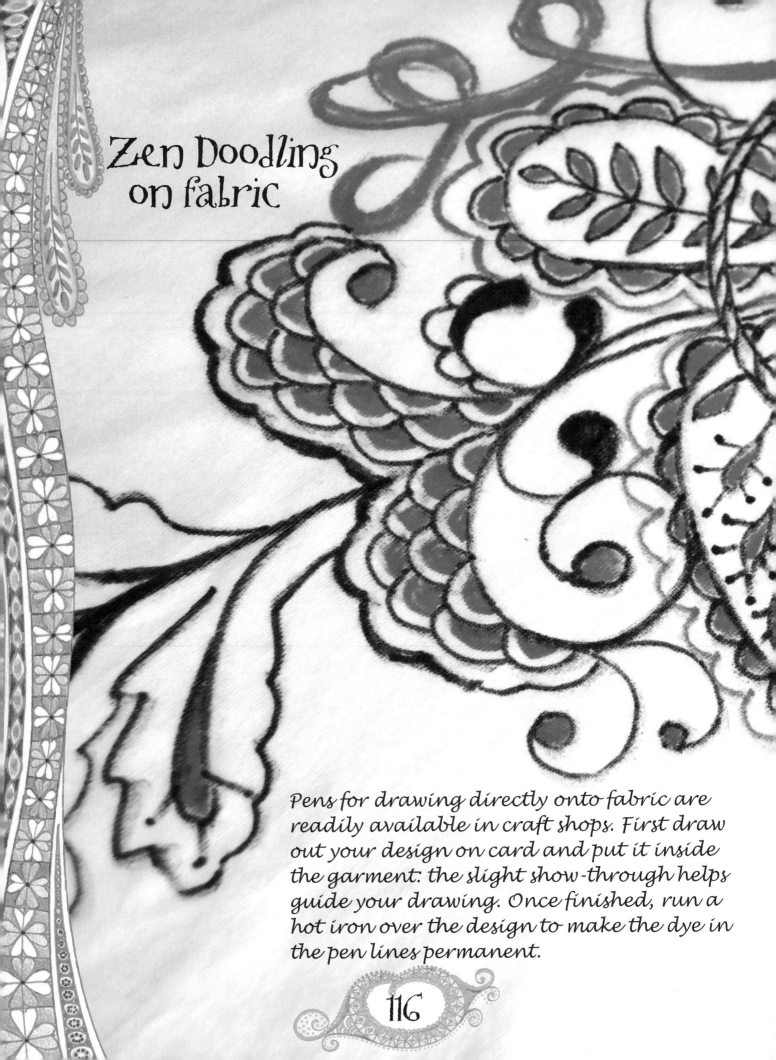

Zen Doodling on fabric

Pens for drawing directly onto fabric are readily available in craft shops. First draw out your design on card and put it inside the garment: the slight show-through helps guide your drawing. Once finished, run a hot iron over the design to make the dye in the pen lines permanent.

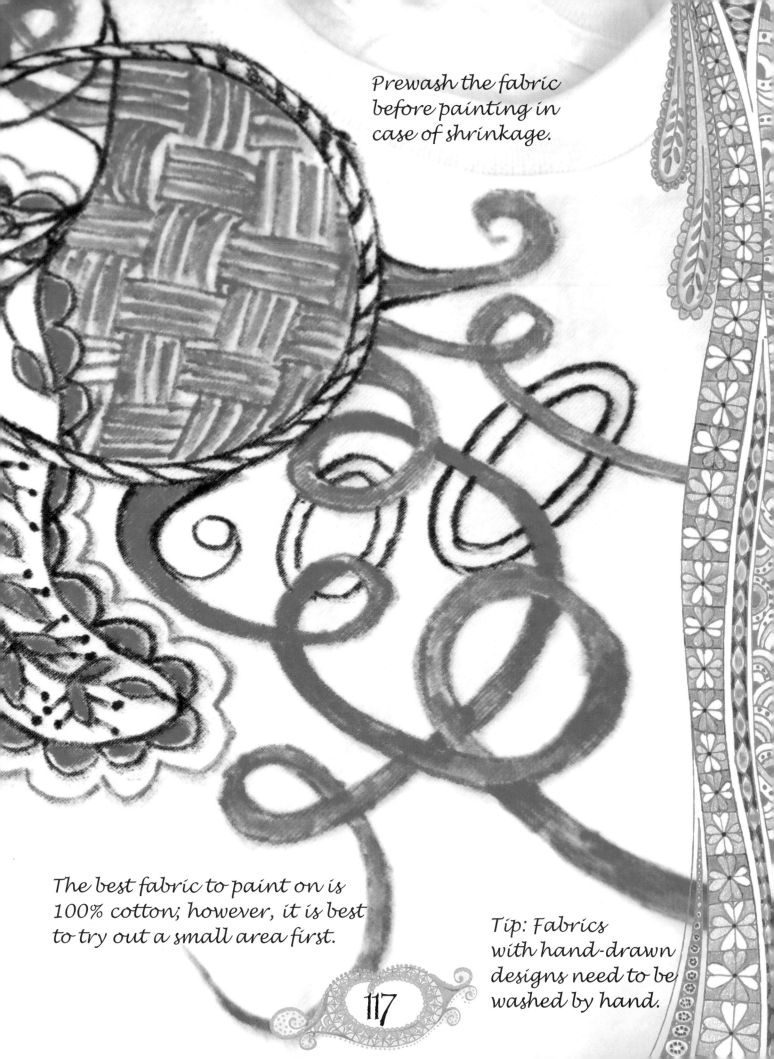

Prewash the fabric
before painting in
case of shrinkage.

The best fabric to paint on is
100% cotton; however, it is best
to try out a small area first.

Tip: Fabrics
with hand-drawn
designs need to be
washed by hand.

Alphabet

The letters of the alphabet are superb shapes to doodle into. It is useful to look at different typefaces in newspapers and magazines before you start drawing your own. Keep the letters chunky-shaped to allow plenty of space for doodling. Study the shape of the letter before deciding on the form your design will take.

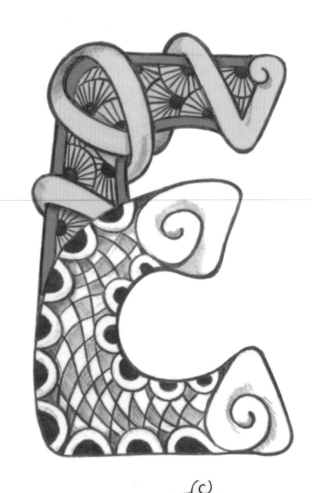

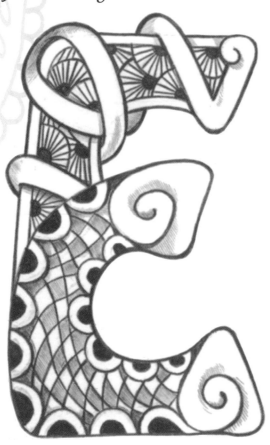

Framing

Add color to some of the letters and leave others black and white. It can look very effective if a letter is partially colored in. If you Zen Doodle a complete alphabet, try mounting all the letters together and framing them. You will be delighted with the result.

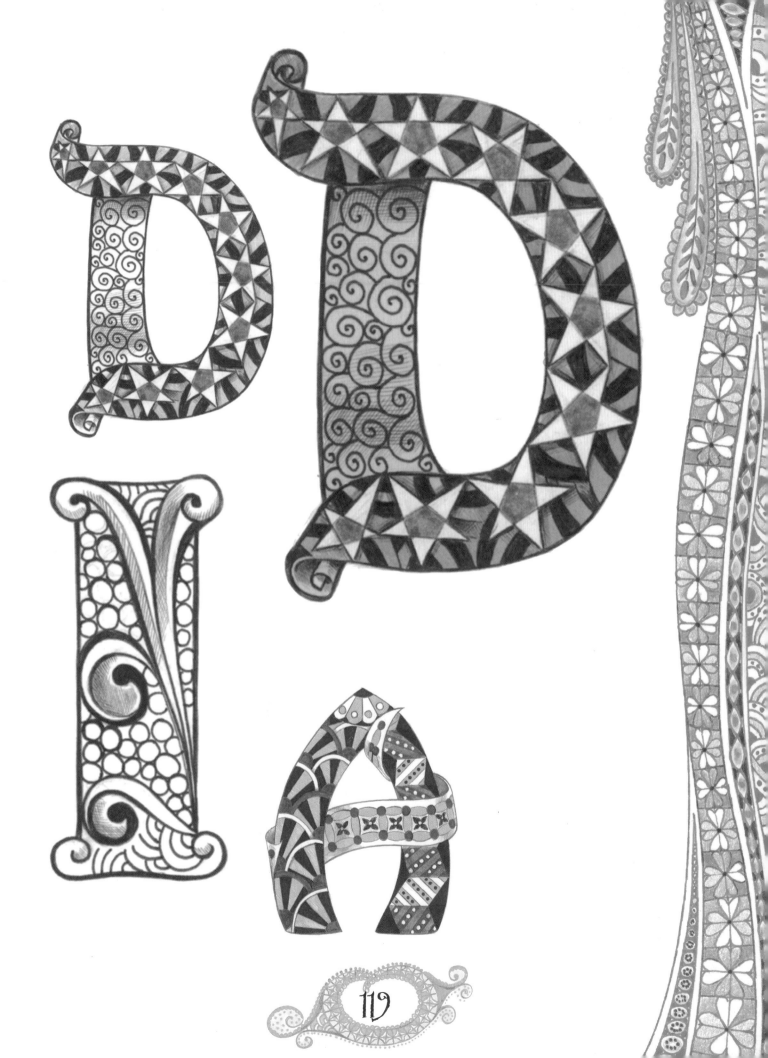

Alphabet

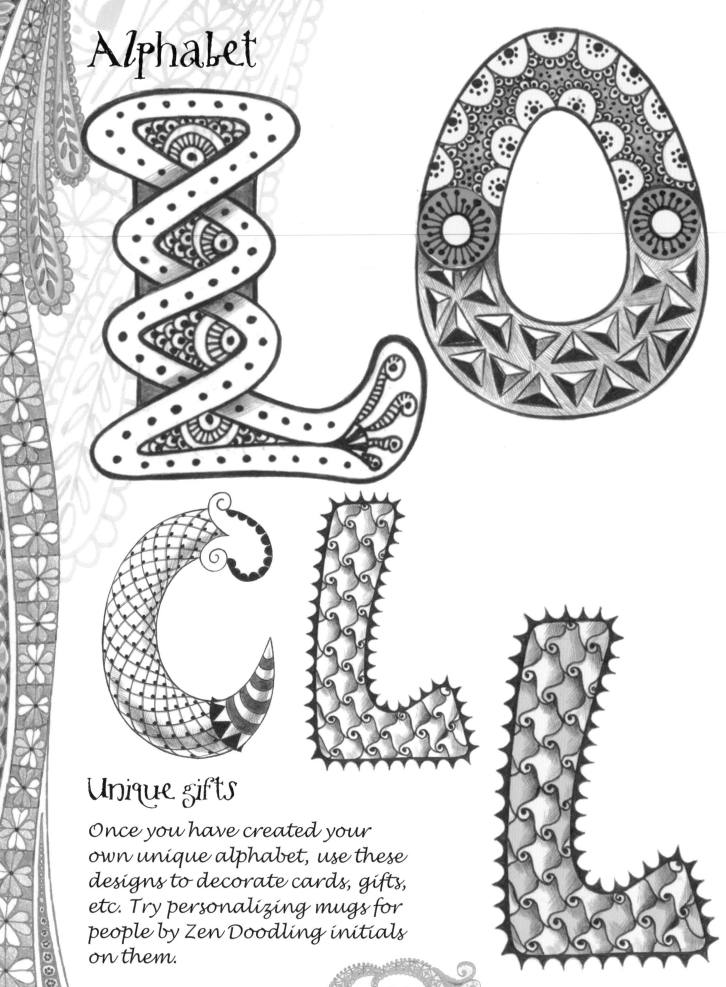

Unique gifts

Once you have created your
own unique alphabet, use these
designs to decorate cards, gifts,
etc. Try personalizing mugs for
people by Zen Doodling initials
on them.

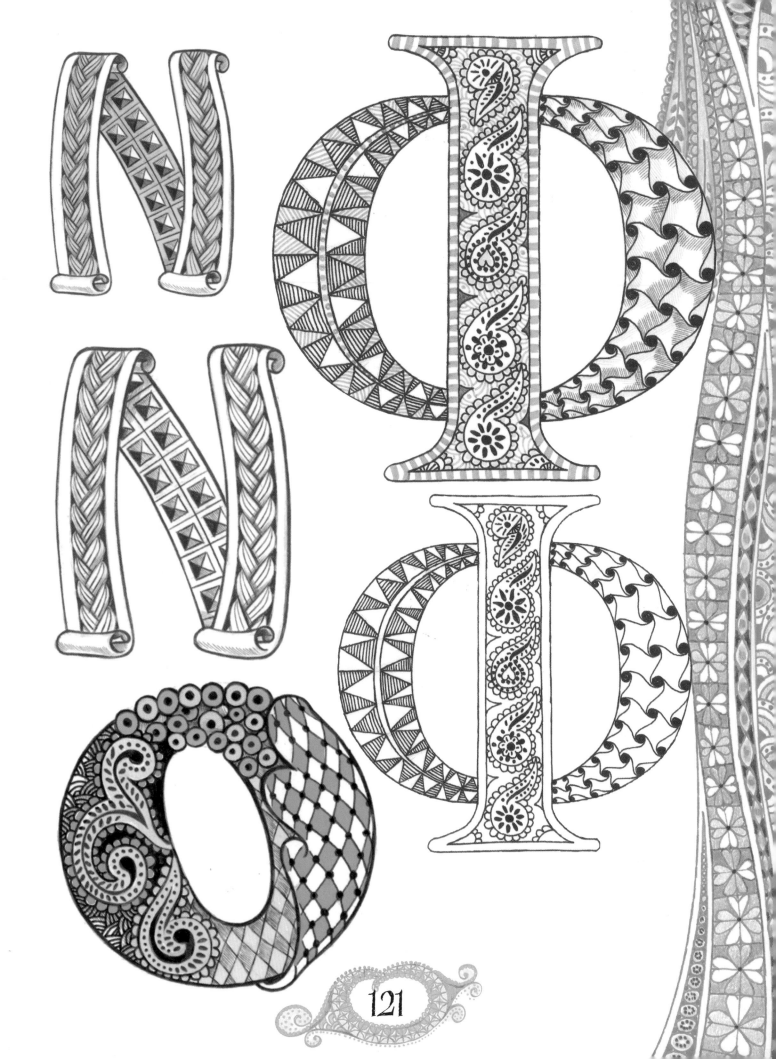

Alphabet

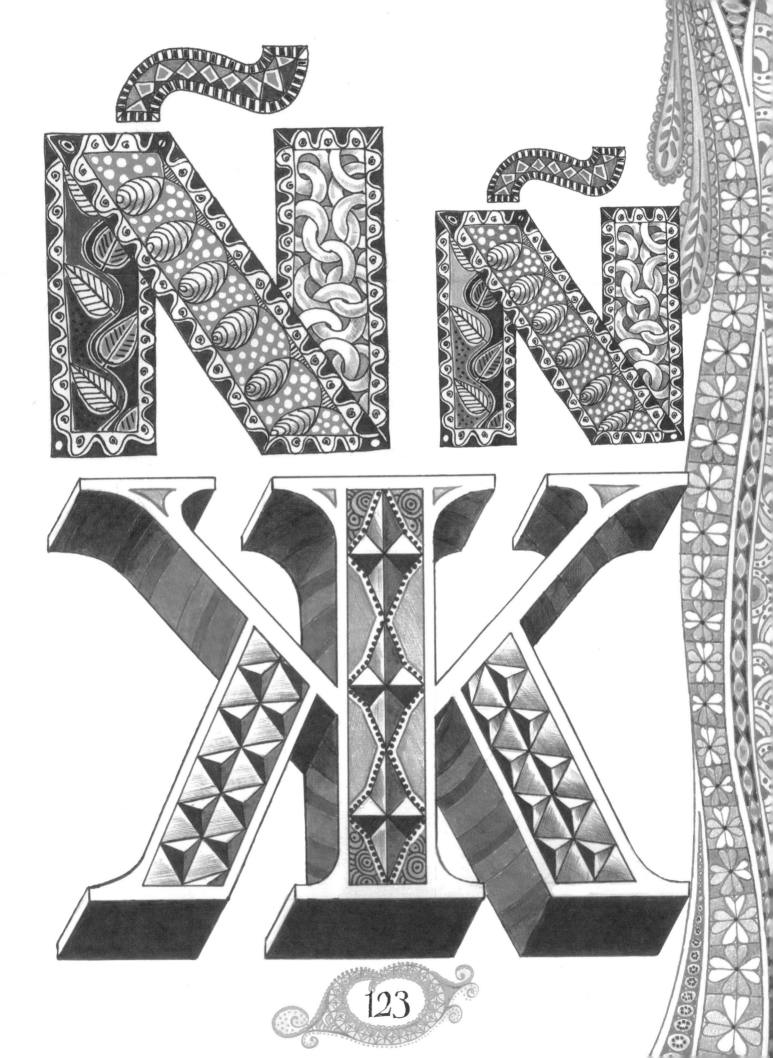

Alphabet

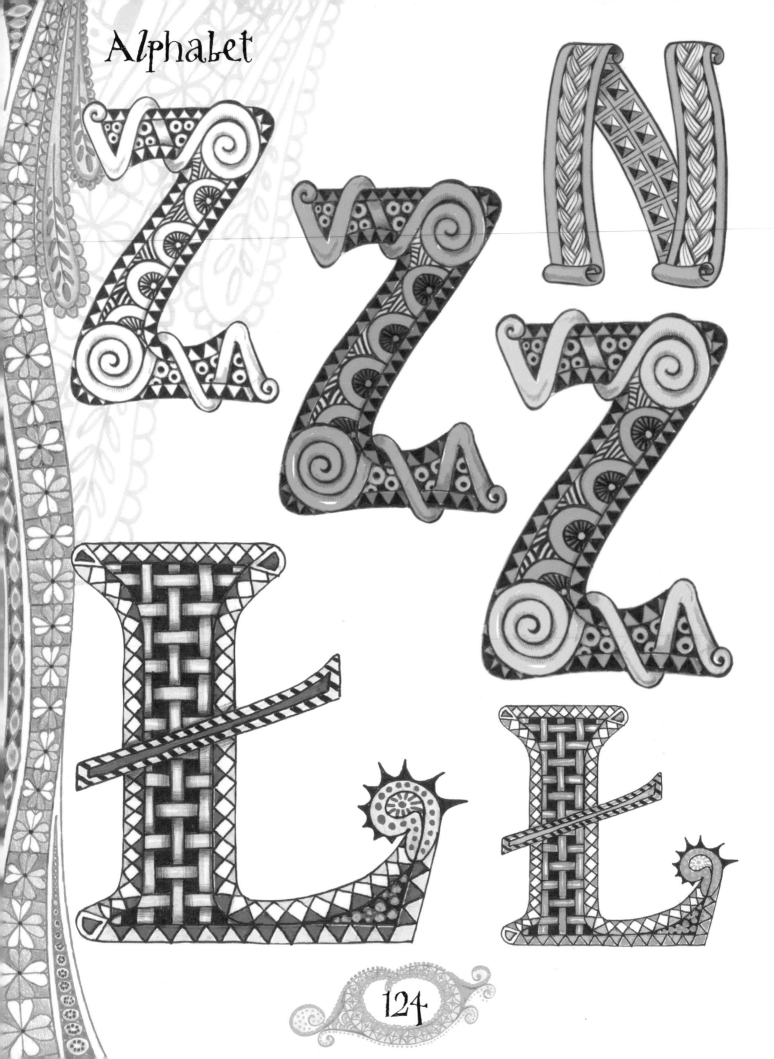

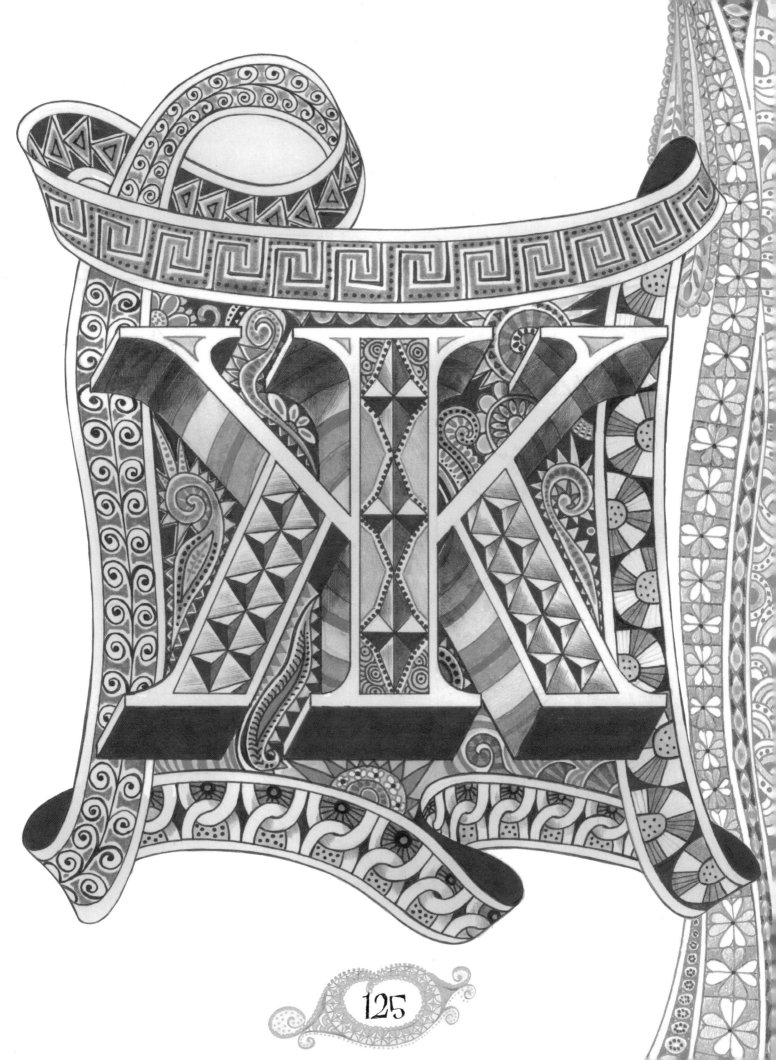

125

Glossary

Ammonite the fossilized shell of an ancient sea-dwelling cephalopod.

Analogous colors harmonious colors that are next to each other on the color diagram/wheel (page 25).

Background the area behind the main object or image.

Collage a composition of materials and objects pasted over a surface, often with unifying lines and color.

Color temperature the warmth or coolness of a color (red-orange is warmest, blue-green is coolest).

Complementary colors those that are opposite to each other on the color diagram/wheel (page 25).

Deconstruct to break down into basic components.

Embellish make more attractive by the addition of decorative details or features.

Embossing a carved or molded design on a surface so that it stands out in relief.

Enlightenment the attainment of spiritual knowledge or insight.

Graphic representation depicting in a vivid, clear, and effective way.

Hue the name of a color.

Intensity a measurement of how different from pure gray a color is.

Layout an arrangement, plan, or design.

Limited palette a restricted number of colors.

Meditation to still the mind, focus it away from the everyday concerns of your talking self, and to listen inward.

Monochrome using a range of tones of a single color.

Paisley an intricate pattern of curved, feather-shaped figures.

Pencil hardness indicated by an H and produces pale lines.

Pencil softness indicated by a B and produces dark lines.

Primary colors a group of colors from which all other colors can be obtained by mixing.

Proportion the size, location, or amount of one part of an image in relation to another.

Resist using a medium to create a design, then applying a wash of color over the design to create a desired effect.

Secondary colors result from mixing two primary colors.

Shading the lines or marks used to fill in areas or represent gradations of color or darkness.

Sketch a quick, undetailed drawing.

Symbolism the representation of something in symbolic form.

Symmetry formed by similar parts facing each other or around an axis.

Technique the method used to produce something.

Tertiary color a color made by mixing one primary color with one secondary color.

Thumbnail (sketches) usually very small, quick, abbreviated drawings.

Tonal value the light or dark of part of an image independent of its color.

Index